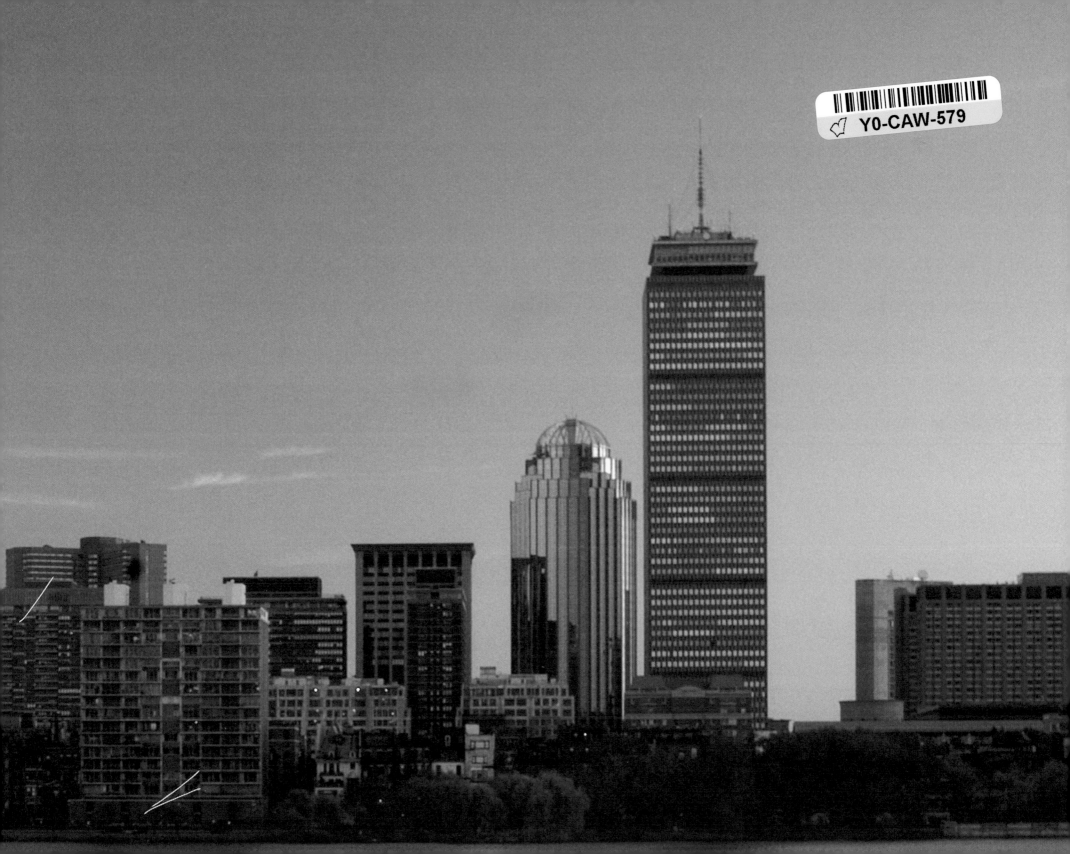

BOSTON WIDE

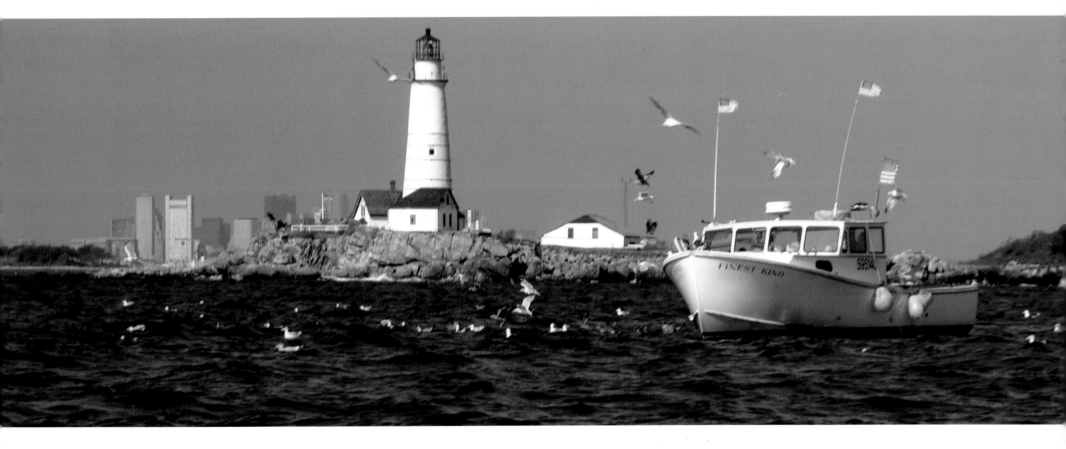

4880 Lower Valley Road, Atglen, Pennsylvania 19310

The Panoramas of
A. P. Richmond

This book is dedicated to Ava Elizabeth.

Schiffer Books are available at special discounts for bulk purchases for sales promotions or premiums. Special editions, including personalized covers, corporate imprints, and excerpts can be created in large quantities for special needs. For more information contact the publisher:

Published by Schiffer Publishing Ltd.
4880 Lower Valley Road
Atglen, PA 19310
Phone: (610) 593-1777; Fax: (610) 593-2002
E-mail: Info@schifferbooks.com

For the largest selection of fine reference books on this and related subjects,
please visit our web site at www.schifferbooks.com
We are always looking for people to write books on new and related subjects.
If you have an idea for a book please contact us at the above address.

This book may be purchased from the publisher.
Include $5.00 for shipping.
Please try your bookstore first.
You may write for a free catalog.

In Europe, Schiffer books are distributed by
Bushwood Books
6 Marksbury Ave.
Kew Gardens
Surrey TW9 4JF England
Phone: 44 (0) 20 8392-8585; Fax: 44 (0) 20 8392-9876
E-mail: info@bushwoodbooks.co.uk
Website: www.bushwoodbooks.co.uk

Cover: The Back Bay skyline at sunset.
Endsheet: The Boston skyline, at sunset, along the Charles River.
Title Page: A lobster boat pulls traps, with Boston Light just beyond and the city skyline in the distance.

Designed by Mark David Bowyer
Type set in Americana BT / Zurich BT

ISBN: 978-0-7643-3273-9
Printed in China

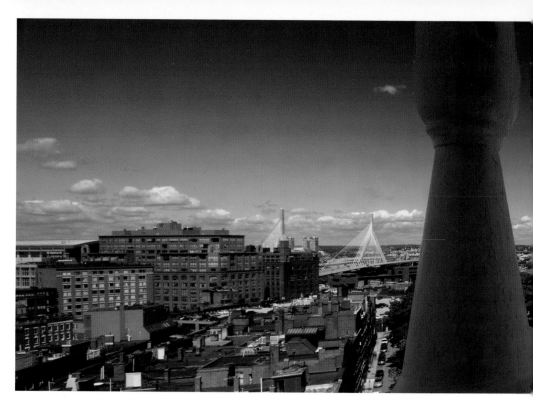

A view north towards the Zakim Bridge taken from the steeple of The Old North Church.

Acknowledgments

As I write more books, it seems that more and more people have contributed their expertise to make these projects both successful and rewarding. In addition, numerous individuals I have met in passing, while taking these images, have suggested other locations that they considered picturesque and essential for a book on panoramas of Boston. To all the directors, curators, and administrators who opened their doors and allowed me to capture images, even if they were not used in this book, thank you. Especially to the executive director and staff at the Old North Church who allowed me access to areas few have visited, thank you. To all the guides and rangers located at historic sites throughout the city that answered my questions and offered explanations. To Tina, Doug, and Peter at Schiffer Publishing who have guided, motivated, and supported my publishing endeavors. To Carol, as always this book would not have been possible. To Doug, Nicole, Jared and Brandi, thanks for the support. To Tony Pane, who for over 30 years has helped me with my writing. To John and Cheryl whose knowledge of the city proved invaluable. And to Salty Dog, my best friend.

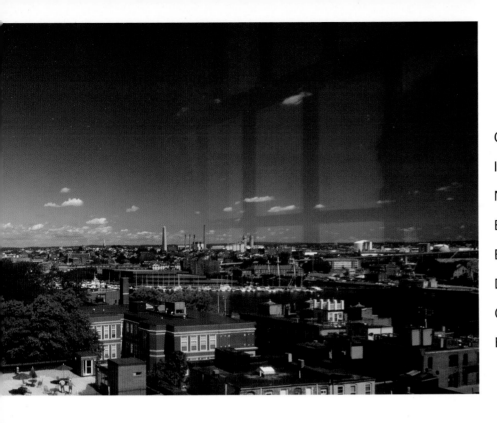

Contents

The Rose Kennedy Greenway looking south from Causeway Street.

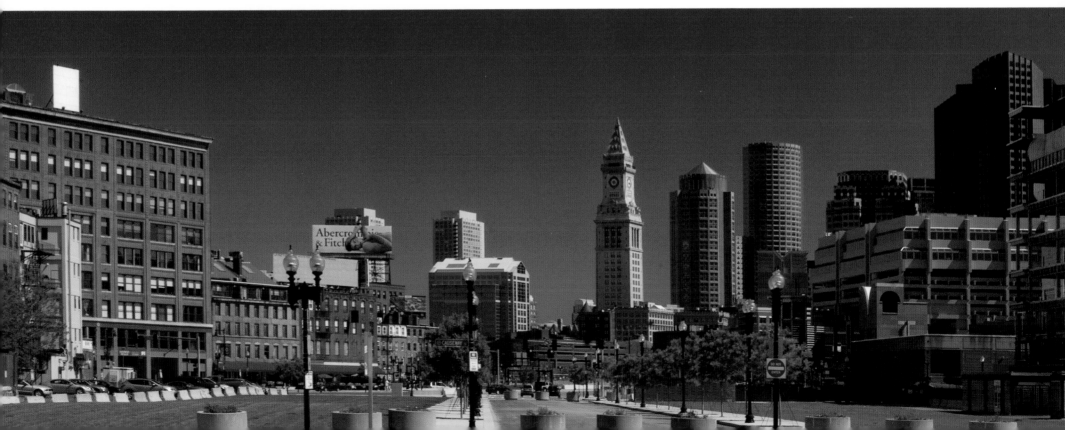

A sailboat cruises the Boston inner harbor.

Introduction

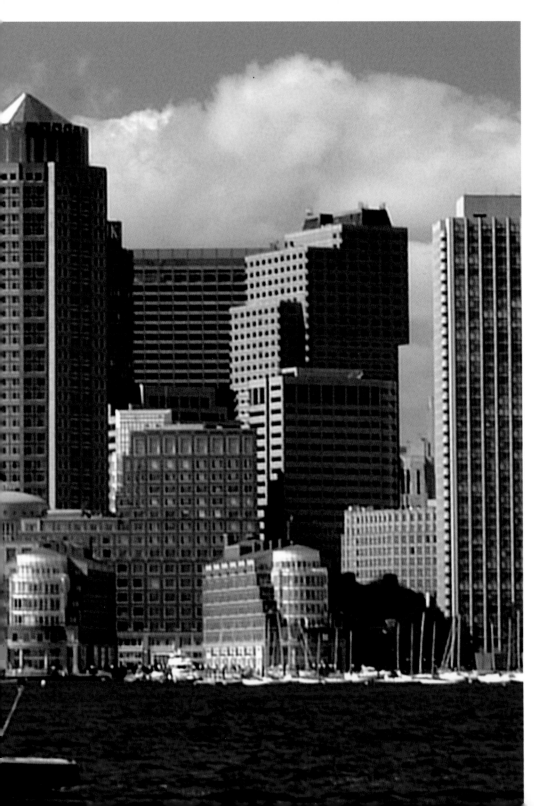

S ince the beginning of photography, more than 160 years ago, people have tried to capture wide angle views of their favorite vistas, including cities, harbors, and urban landscapes. The inspiration for these photographic images was probably "The Panorama," a huge picture of Edinburgh, Scotland, painted by Robert Barker and displayed in London in 1792. In America, probably the most famous panoramic painting is the Cyclorama, which measures 42 by 358 feet. First displayed in Detroit in 1887, the picture depicts the Civil War battle of Atlanta and is now on permanent exhibit in that city. Boston was, and still is, a favorite subject for panoramic photographers. Because of this there are numerous historical images of this fascinating city; several, from different neighborhoods, are included here.

Photographers using film were limited in the panoramic pictures that they could shoot. Using specially designed cameras they could capture a scene with wide angle views of more than 150 degrees and even up to 360 degrees were possible, but it necessitated the development of photographic paper large and long enough to print the scene. In this book old images can be seen that are made up of more than one sheet of paper.

Enter the world of digital photography. Now with appropriate camera equipment, skill with the computer, and photo-editing software, the serious photographer can produce outstanding panoramas. Since human stereovision is about 120 degrees, the images in this book are in that range and consist of two or three images that have been "stitched" together. Some were shot with a wide-angle lenses.

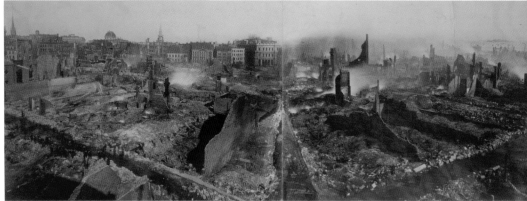

This panoramic image was taken after the Boston fire of November 9th and 10th, 1872. The original albumen print was 12" by 32" and created by Joshua Smith (Courtesy of Library of Congress).

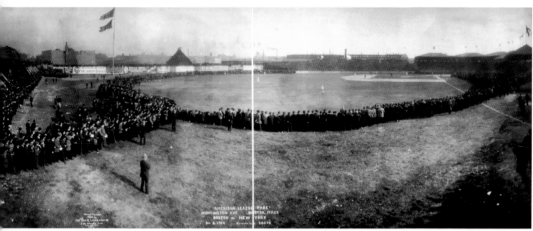

This panorama of the American League Park on Huntington Ave was taken on October 8, 1904, when Boston was playing New York. The attendance for the game was 28,040. Photographed by the George R. Lawrence Co. of Chicago, Illinois, the gelatin print measured 18.5" by 46" (Courtesy of Library of Congress).

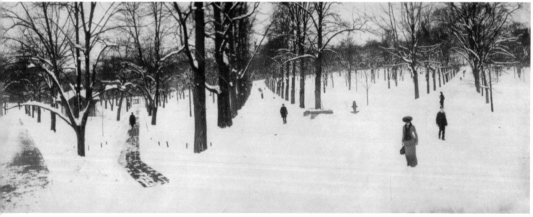

This snow scene taken of Boston Common on Jan. 10, 1904, is a silver printing out paper that measures 11" by 28" (Courtesy of Library of Congress).

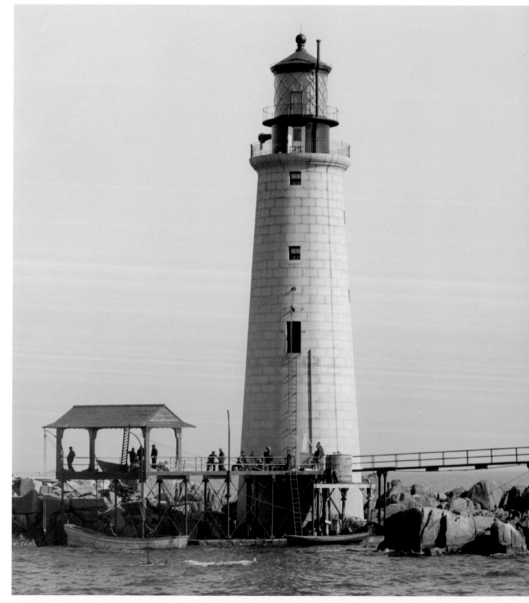

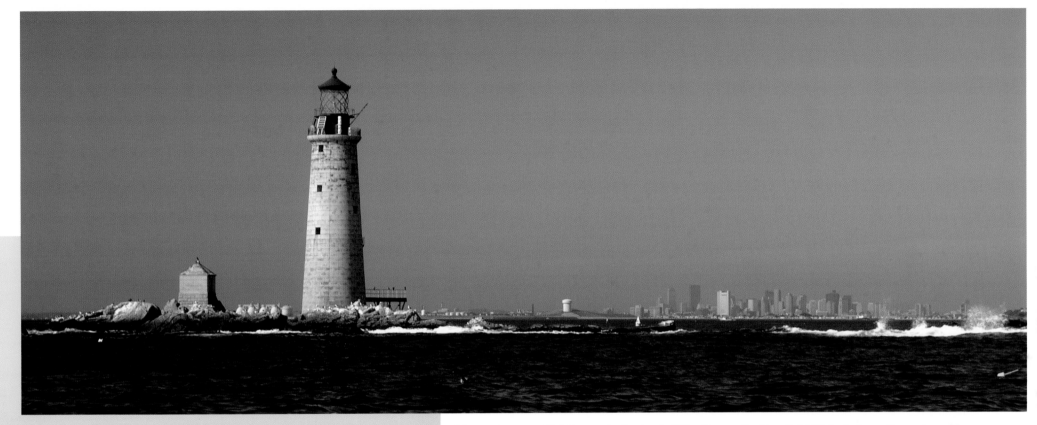

The easternmost lighthouse in Boston is "The Graves," with a light 98 feet above the water with a range of 24 nautical miles. It welcomes mariners into Boston Harbor and can be seen from the shore in the distance, through the Broad Sound Channel. Construction of the lighthouse began in 1903, with blocks of granite from Cape Ann, and it was completed two years later. The light was activated on September 1, 1905. 30 feet in diameter at the base and 113 feet tall, the lighthouse consists of six decks, including an engine room, a galley, crew's quarters, a library, a watch room, and an extra large lantern room that used to have a 1st order Fresnel lens. The black and white image was shot during the early 1900s and shows the walkways and structures that were destroyed by a hurricane in 1991. Automated in 1976 with a modern lens, the light can be seen from several shore locations (Courtesy of Library of Congress).

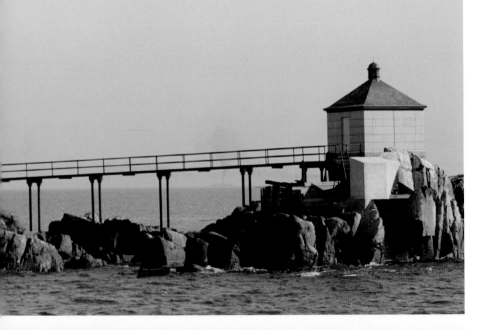

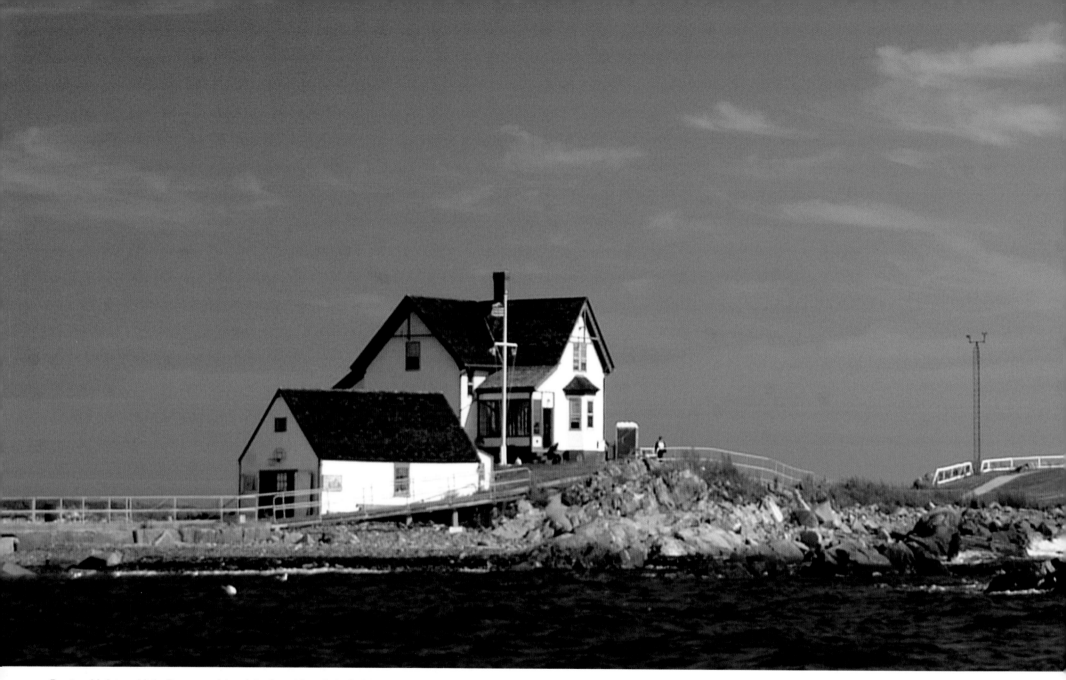

Boston Light on Little Brewster Island, is the oldest light in North America. The island was named after the Mayflower Brewsters, and a bonfire or beacon may have been lit to guide navigators as early as 1679. The original tower was built in 1716, but was destroyed by the British when leaving Boston during the American Revolution in 1776. Incidentally, Sandy Hook lighthouse in New Jersey, is the oldest active lighthouse in America only because attempts to destroy it, to prevent it from falling under British control during the Revolution, failed to destroy the tower. The present Boston Light tower was built in 1783 with extensive repairs and the installation of a 2nd order Fresnel lens in 1859. The light is now automated and open to the public for tours.

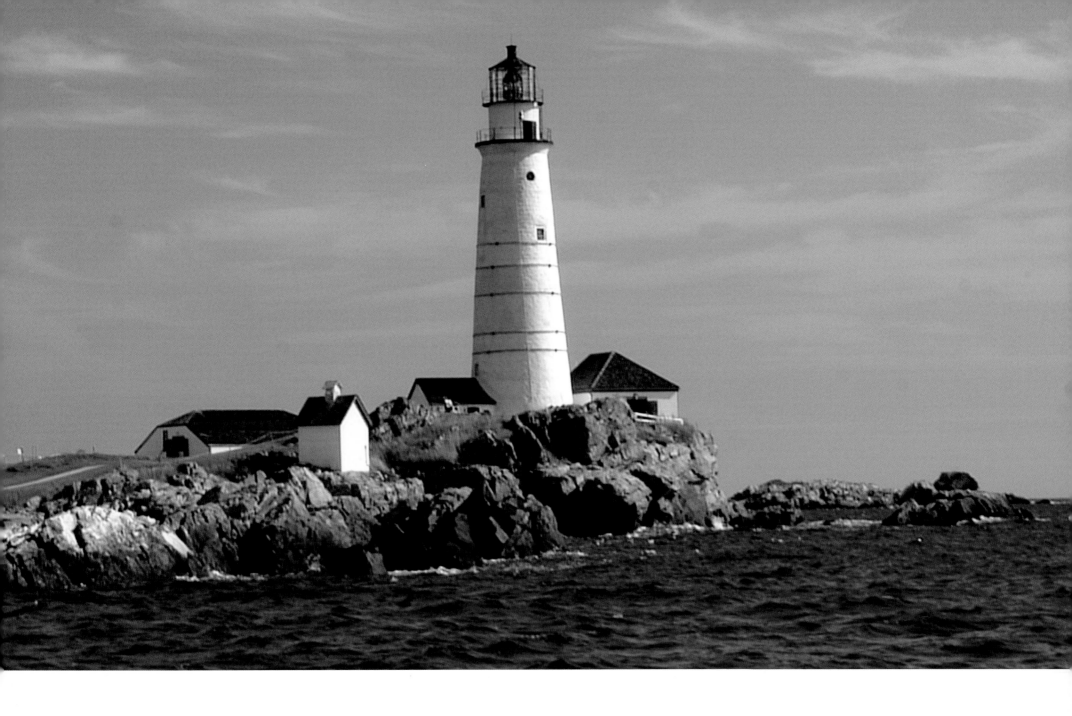

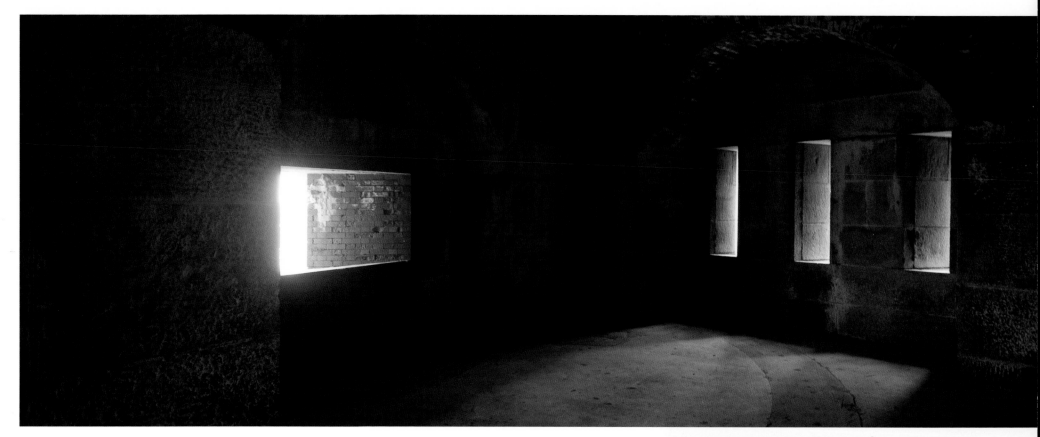

Georges Island, in the outer harbor, is the site of Fort Warren. A strategic location protecting the entrance to the harbor, the island was originally fortified by the French during the American Revolution. Named for Major General , Dr. Joseph Warren, who died at the battle of Bunker Hill, construction of the fort began in 1833. It was used during the Civil War as a prison and later as a fort, until it was decommissioned in 1951. It is now open to the public and part of the Boston Harbor Islands national parks area. Inside the fort is this corner bastion overlooking the nearby waters. The parade ground was used for training, inspections, and recreation. Large windows on these inner walls allowed the airflow and light that the small openings on the exterior walls did not.

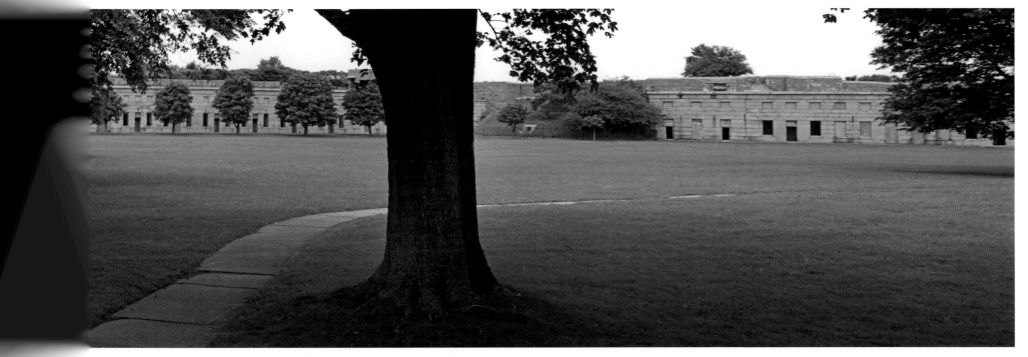

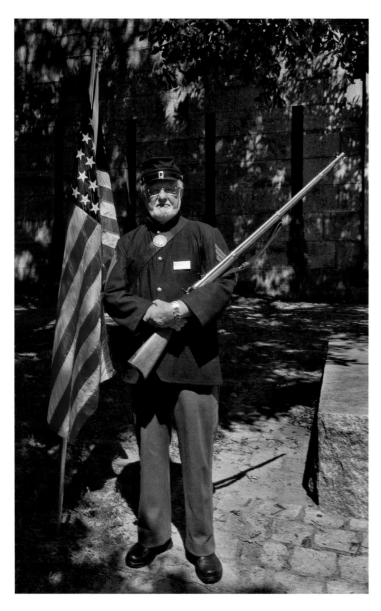

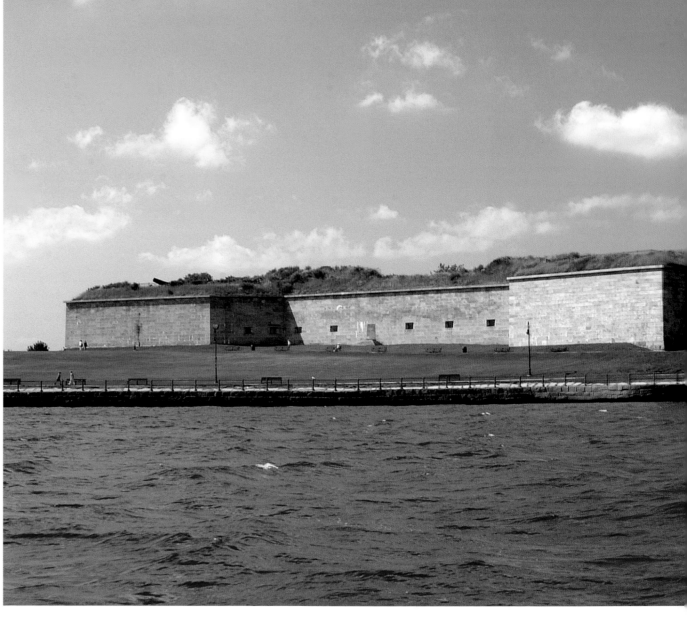

Fort Independence on Castle Island, South Boston, is the innermost fort in the harbor, with the channel on the right leading to the inner wharfs and docks. Dorchester Bay is to the left. The first fort, built in 1634, was an earthen work structure with three cannons. A total of eight forts have been built on the site. In 1776, Lt. Paul Revere commanded the troops that repaired the fortifications that were destroyed by the evacuating British. Open to the public on a limited schedule, Fort Independence is on the Register of National Historic Places and offers visitors a glimpse of the past. A soldier in period dress welcomes visitors at the fort gate.

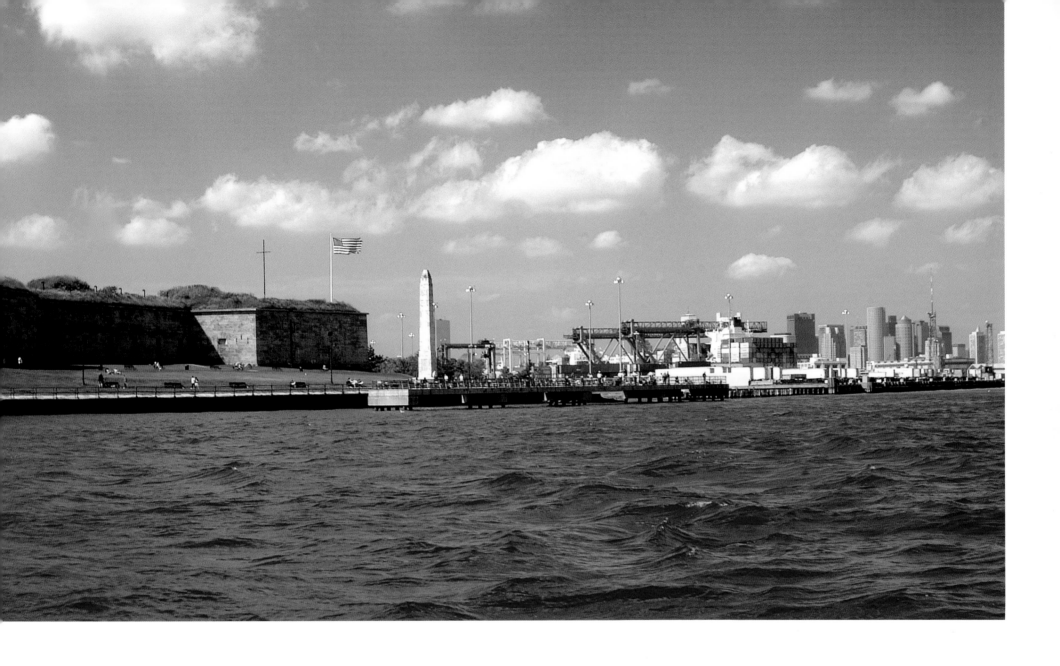

Looking south from Carson Beach in South Boston, the John F. Kennedy Presidential Library, on Columbia Point, dominates the shore. Outstanding exhibits commemorate the 1,000 days of the Kennedy administration, with recreated rooms of the White House and film clips of JFK'S speeches.

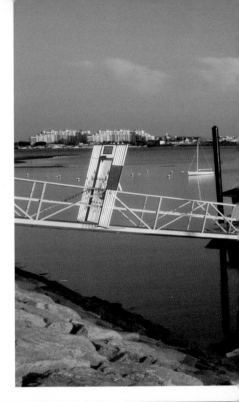

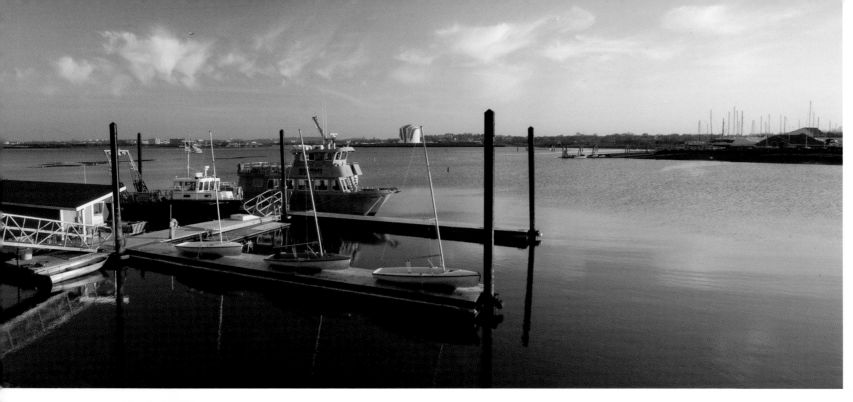

Looking south towards the brightly painted and distinctive gas tank, the UMass-Boston docks accommodate a variety of vessels that are used for marine research and education. The second view is of Malibu Beach, looking west at sunset, towards the Dorchester Yacht Club.

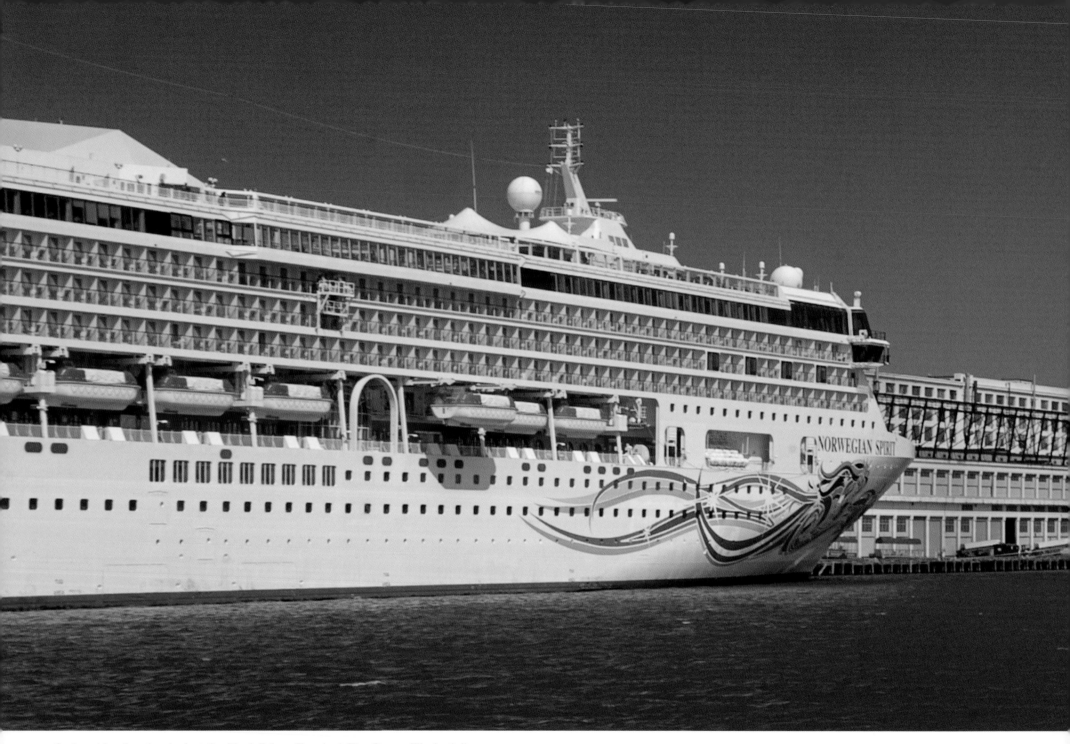

Cruise ships line the dock at the Black Falcon Terminal. The Queen Elizabeth II in the distance appears dwarfed by the modern ocean liners.

The fish pier offers dockage for commercial fishing vessels to unload their catch. Local restaurants provide freshly caught seafood.

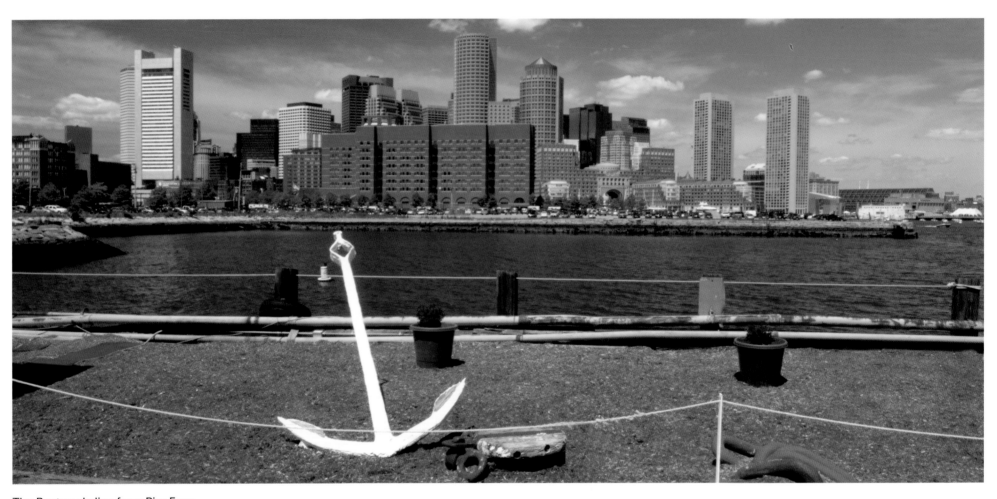

The Boston skyline from Pier Four.

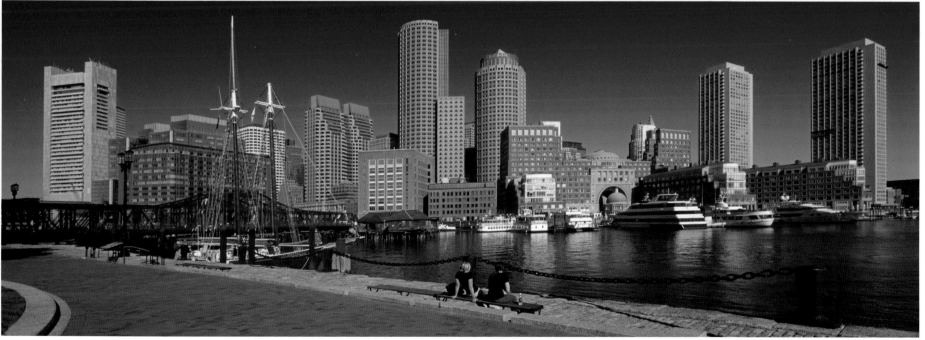

Two views from Fan Pier. The top picture looks east towards the airport at sunset and the bottom one looks west towards the city during the daytime.

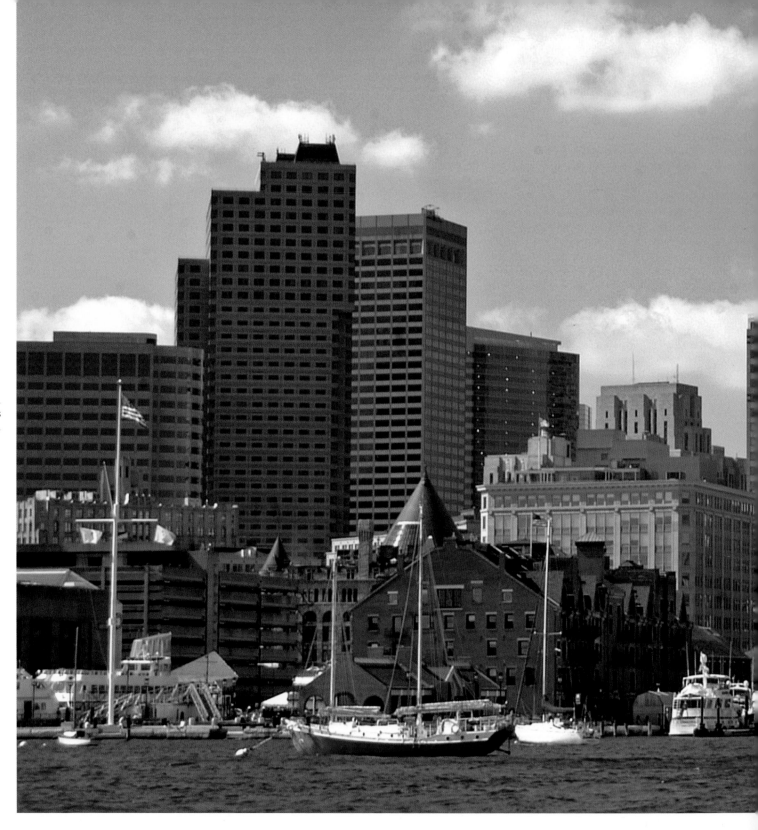

The Boston skyline from the water. The distinctive Custom House tower is a point of reference.

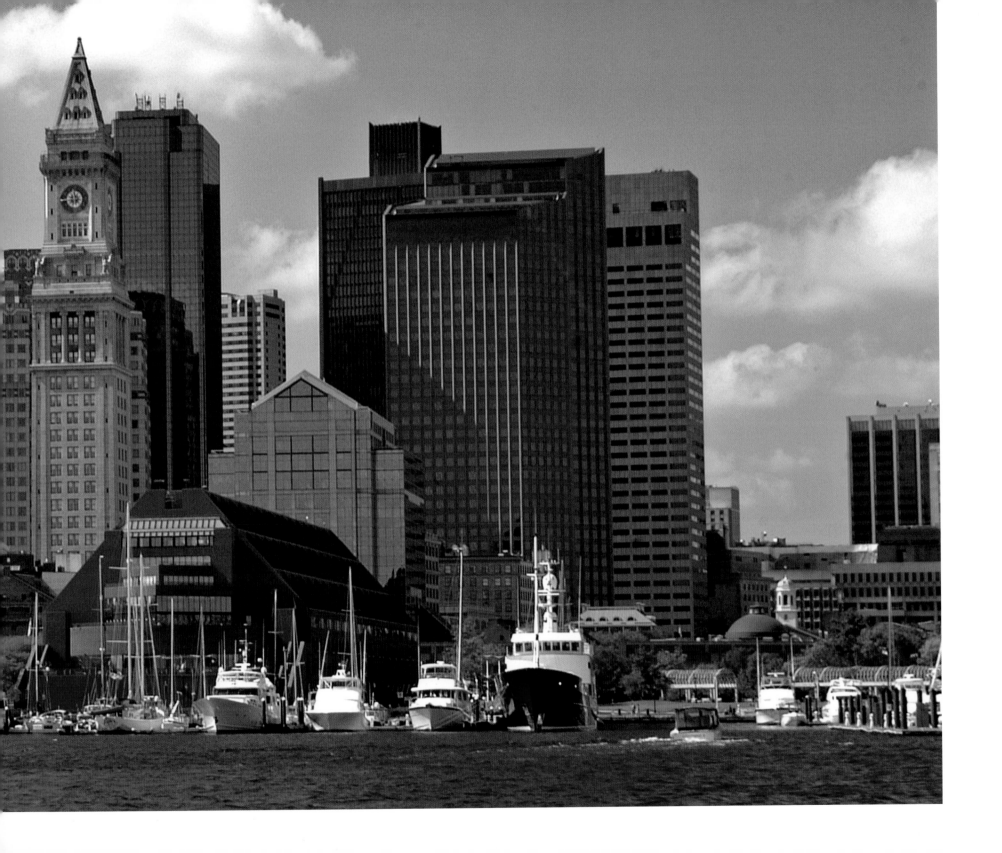

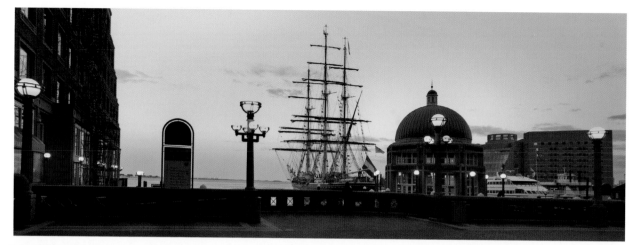

A tall ship at the dock at Rowes Wharf, with the Moakley Federal Courthouse in the background.

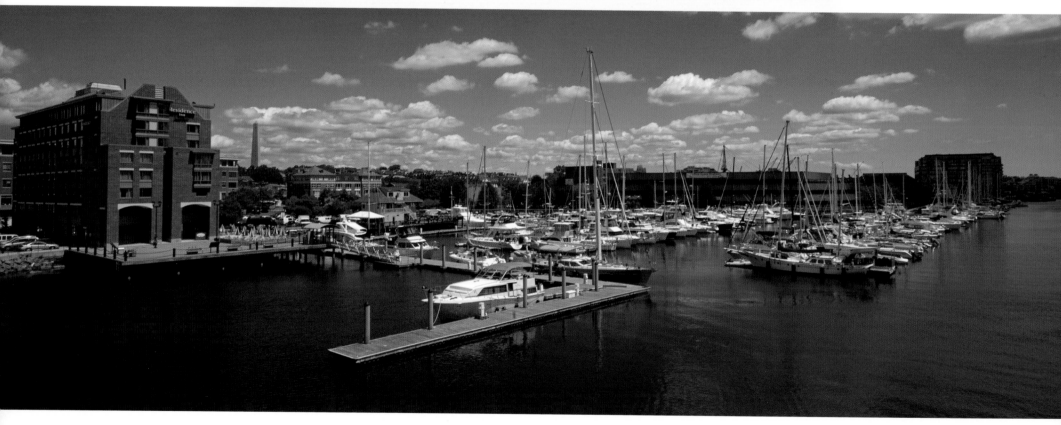

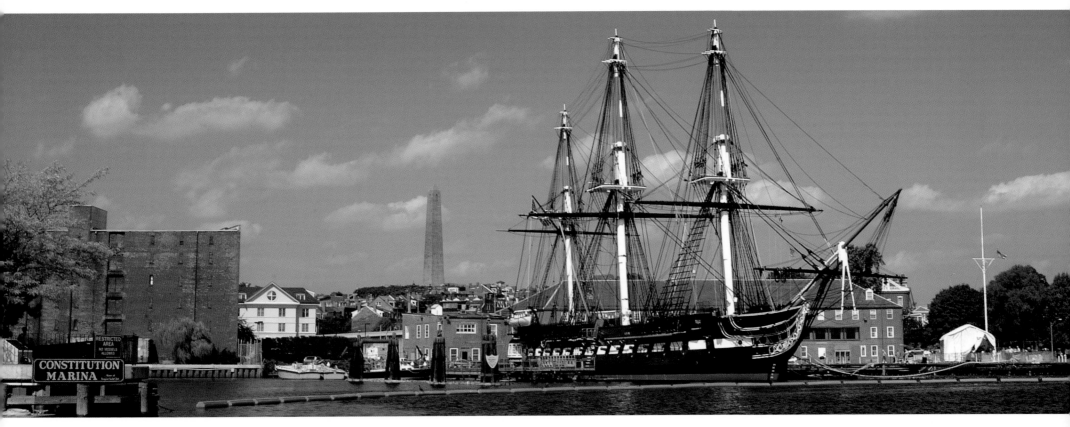

Crossing the Charlestown Bridge from Boston, Constitution Marina and Plaza occupy the waterfront on the left. From the North End, the Bunker Hill Monument and the U.S.S. Constitution are visible along the waterfront. The U.S.S. Constitution, the oldest commissioned warship in the United States, sits at the dock at the Charlestown Navy Yard. Built in the North End in 1797, she earned her famous nickname "Old Ironsides" during the War of 1812, when cannonballs bounced off her sides. "Old Ironsides" is probably the most illustrious ship in U.S. history.

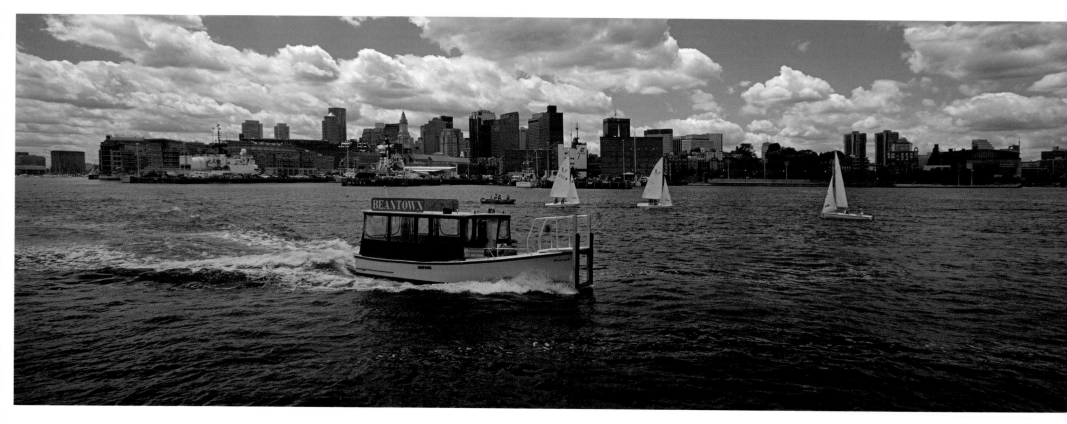

Looking from East Boston, ferries and sailboats
are common sights in the inner harbor.

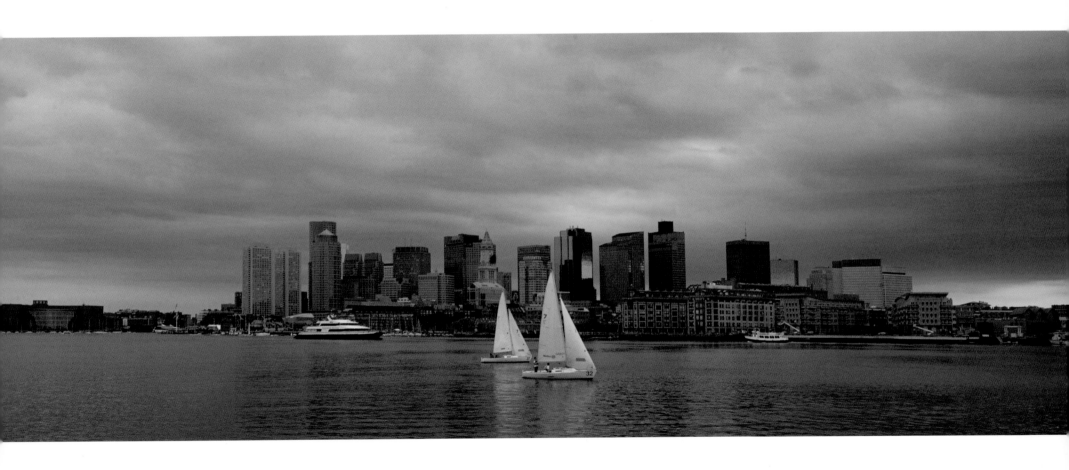

One of the former East Boston docks, where clipper ships were once built, is slowly rotting away. The Tobin Memorial Bridge is in the background, which connects Boston to the North Shore.

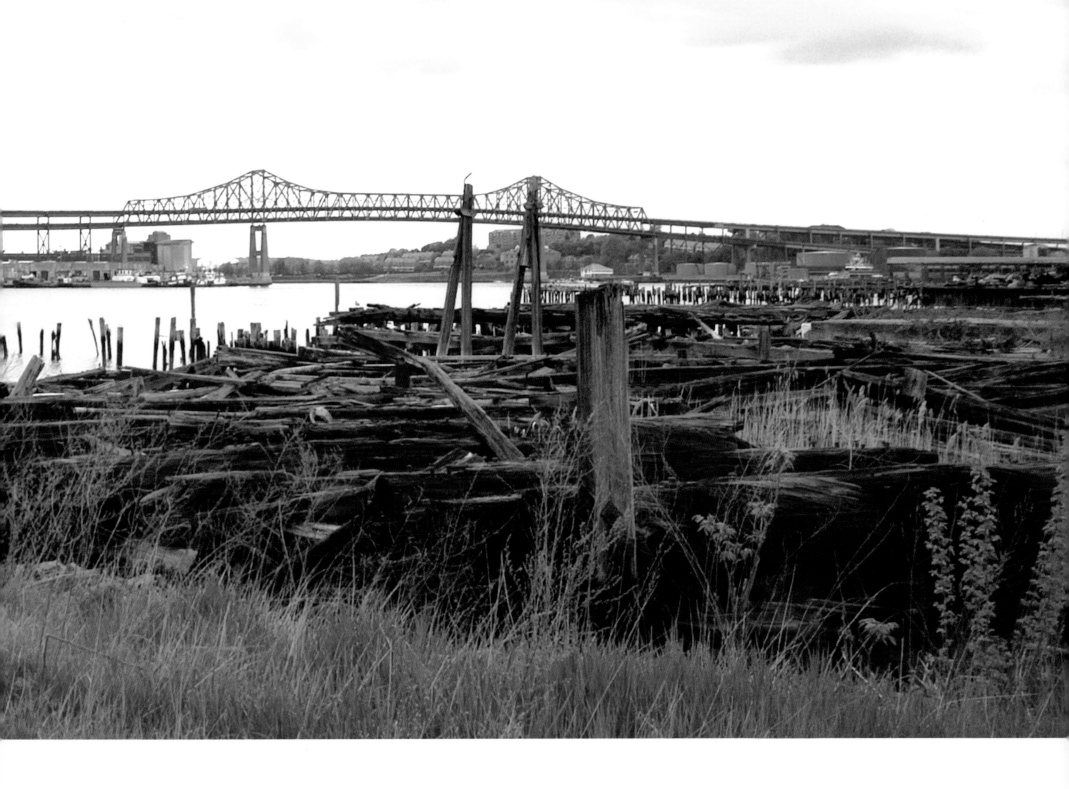

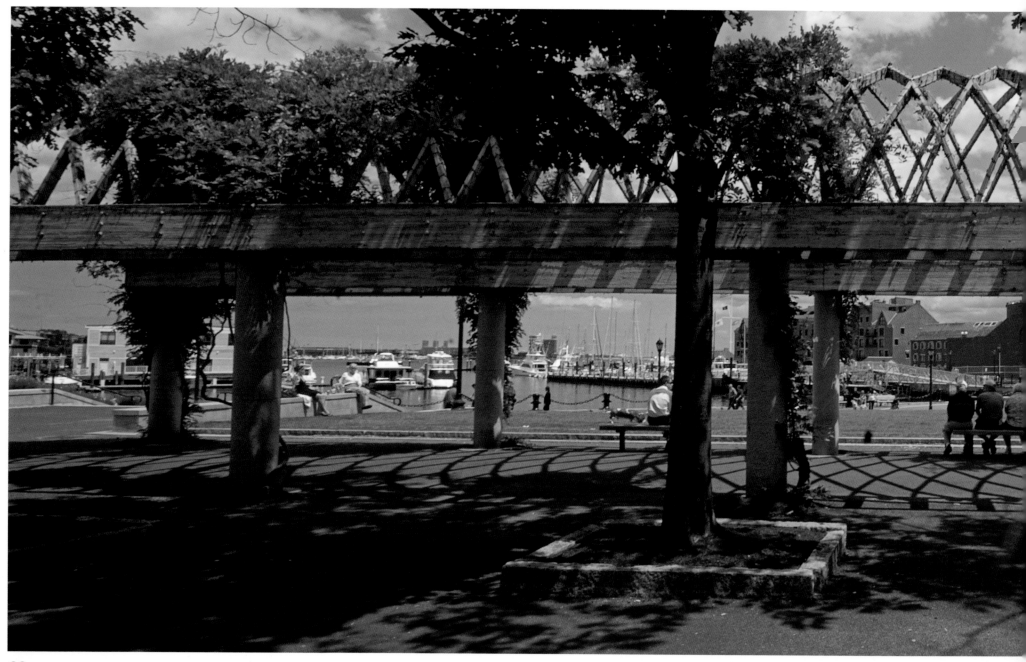

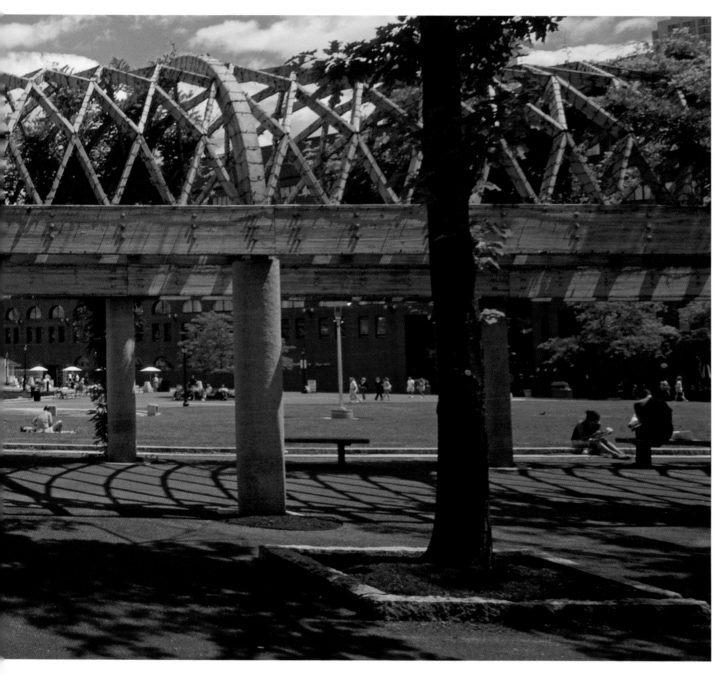

A wisteria-covered walkway, over 300 feet long, welcomes visitors to the North End and Christopher Columbus Park, which has almost five acres of open space.

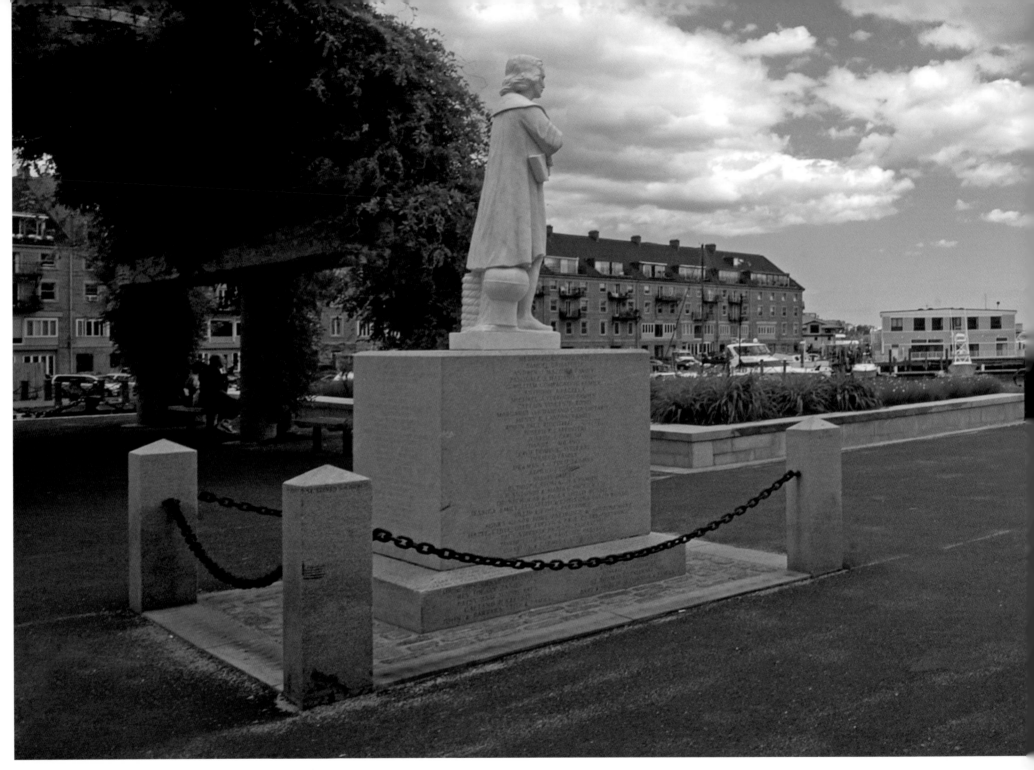

A statue of Christopher Columbus overlooks the harbor between Commercial Wharf on the left and T Wharf on the right.

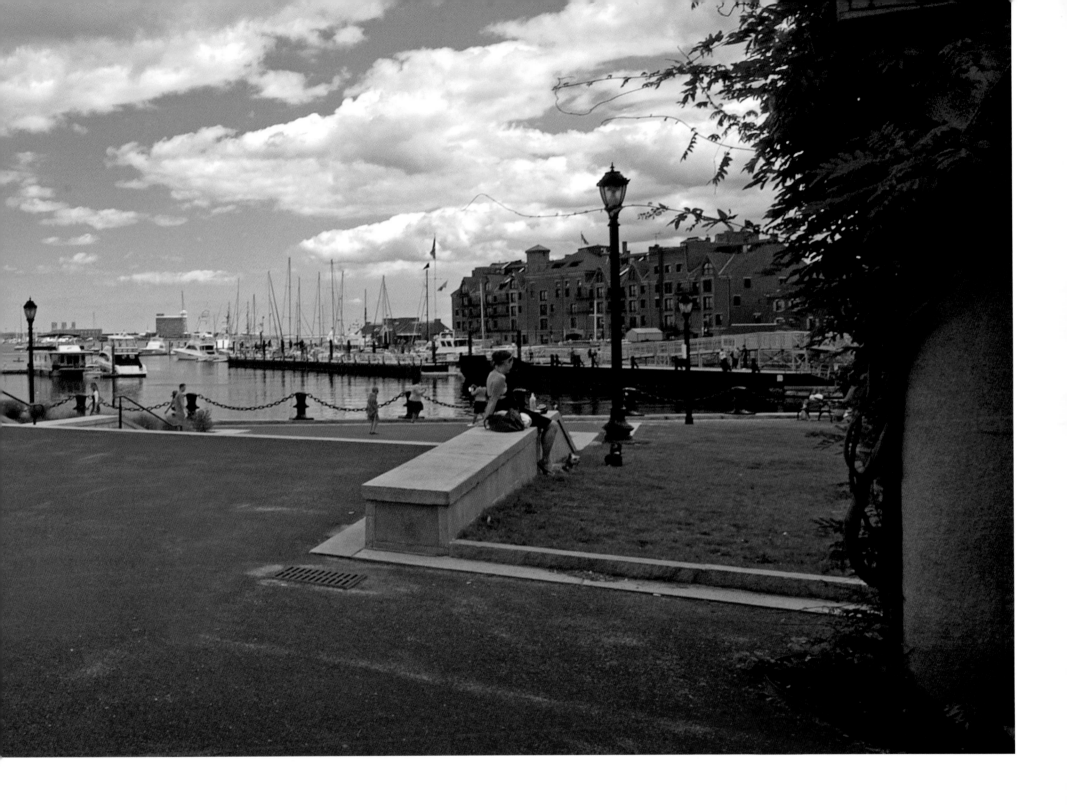

The North End, which is now predominately Italian, is famous for its restaurants.

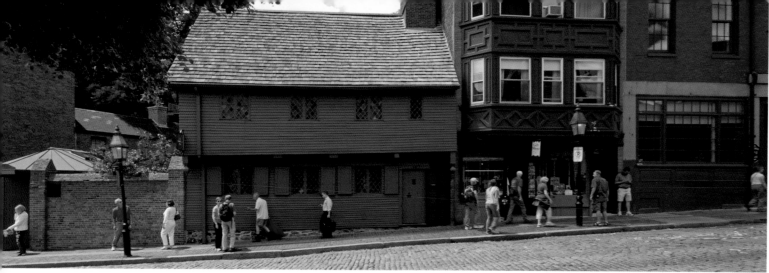

Paul Revere's home, built in 1680, is the only 17th century dwelling left in Boston. Owned by Paul Revere from 1770 to 1800, it was from this location that the famous midnight ride began, which was later immortalized by the Longfellow poem. A stop on the Freedom Trail, the house contains original furniture and artifacts from Revere's workshop.

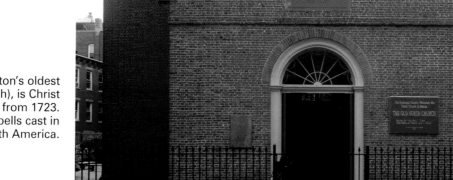

The official name of Boston's oldest church, (Old North Church), is Christ Episcopal Church, dating from 1723. Inside the tower are bells cast in 1745, the oldest in North America.

It is from this steeple that, on April 18, 1775, the signal was flashed to warn the colonists, "The British are coming!"

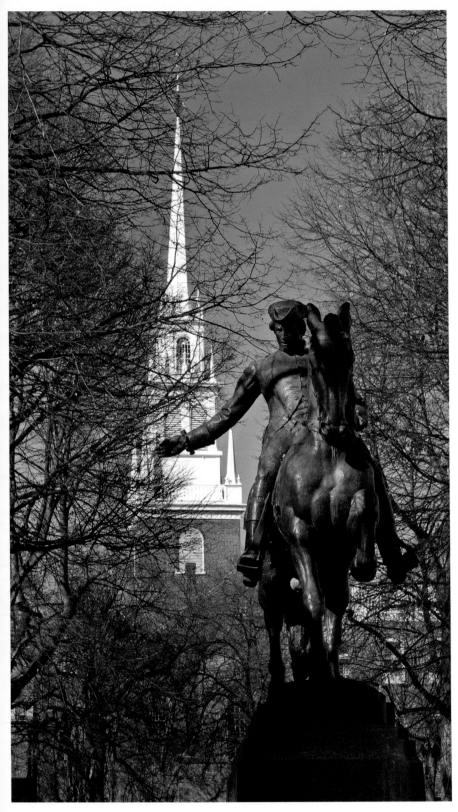

Circular windows are found in the church steeple.

Among the most visited areas within the North End are the Old North Church and adjacent Paul Revere Mall. Connecting Hanover Street to Unity Street, the Mall was laid out in 1933 with the equestrian statue of Paul Revere dedicated in 1940. The Old North Church can be seen in the background.

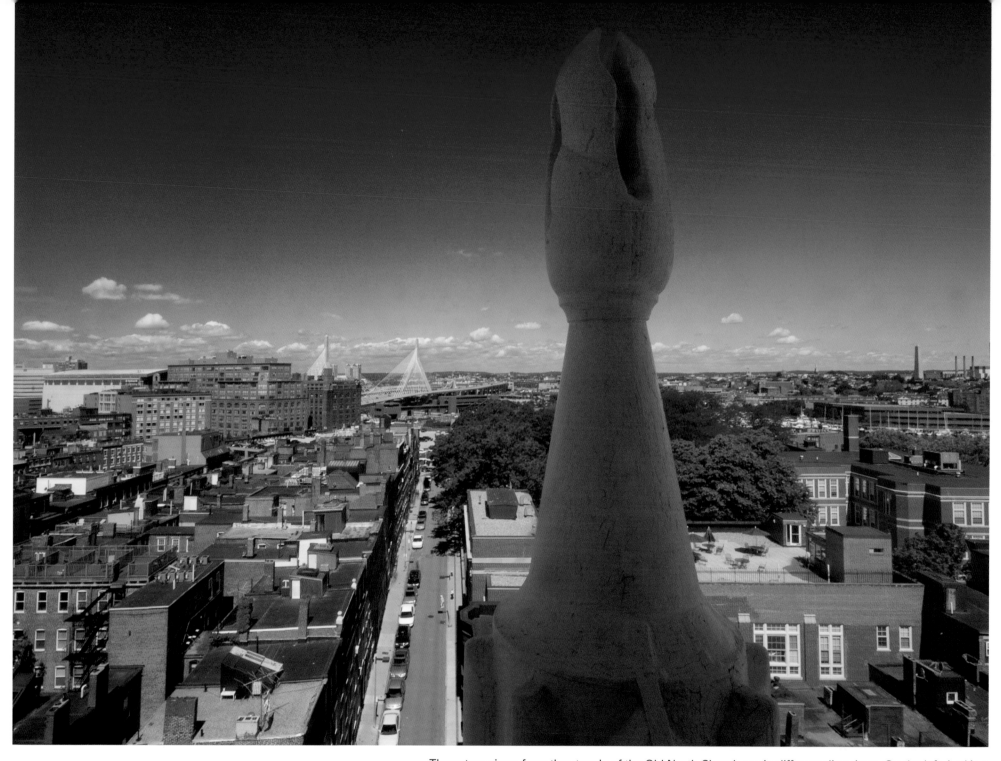

These two views from the steeple of the Old North Church are in different directions. On the left, looking northward, is the vista down Hull Street with the Zakim Bridge in the background. The treed area is the Copp's Hill Burying Ground. On the right, it is possible to see the Bunker Hill Monument, Charlestown and the East Boston shore in the distance.

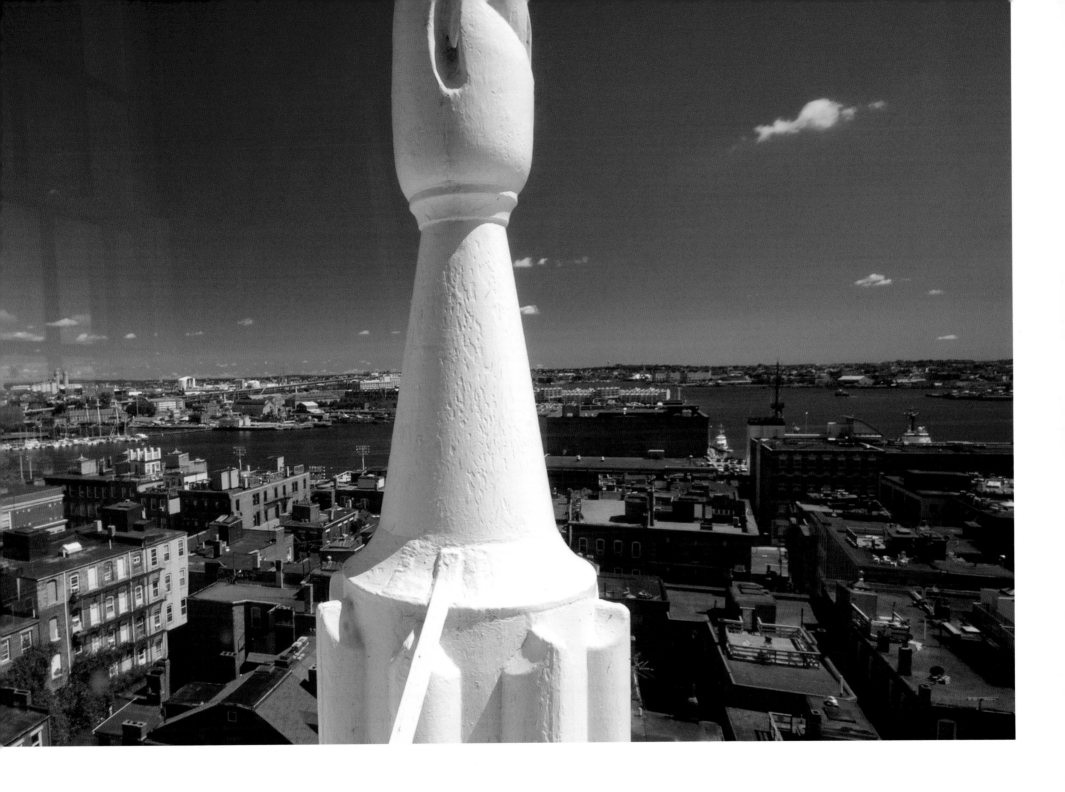

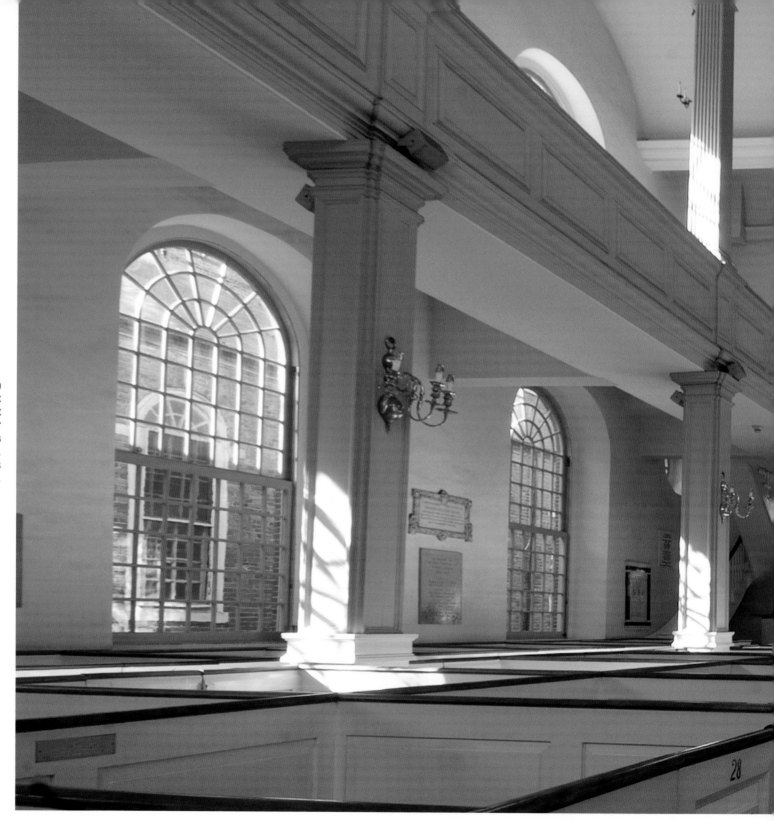

The inside of the Old North Church with its distinctive high-sided box pews. Designed to enclose foot warmers filled with heated bricks or hot coals, the pews kept parishioners warm during the wintery months. Over 250 years old, the candelabras are still lit during evening services.

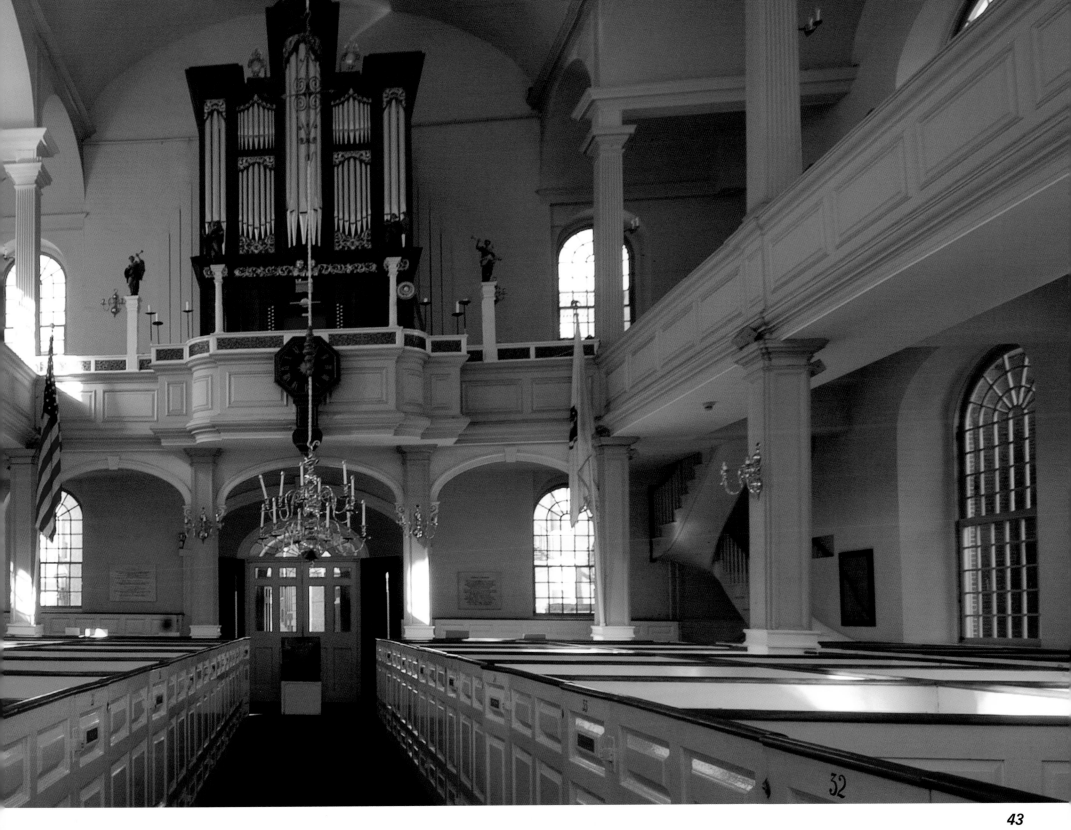

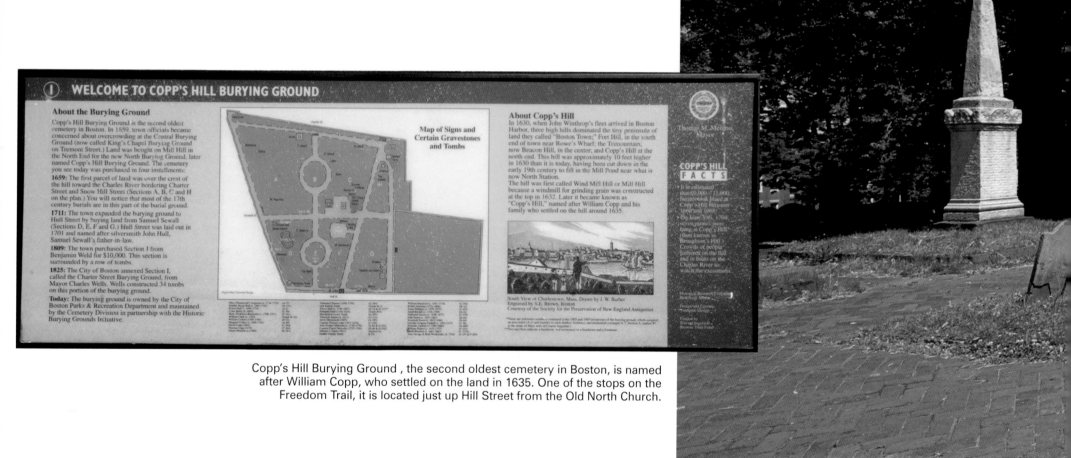

Copp's Hill Burying Ground , the second oldest cemetery in Boston, is named after William Copp, who settled on the land in 1635. One of the stops on the Freedom Trail, it is located just up Hill Street from the Old North Church.

Louisburg Square, on Beacon Hill, is the last private square in Boston. The Greek Revival town houses were built in the 1840's. Notable occupants have included Louisa May Alcott, Robert Frost, Oliver Wendell Holmes, Charles Bullfinch, John Hancock, John Singleton Copley, and currently, Senator John Kerry.

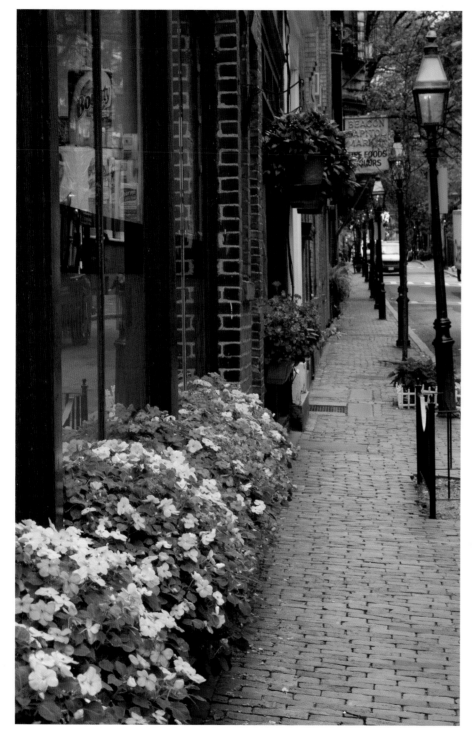

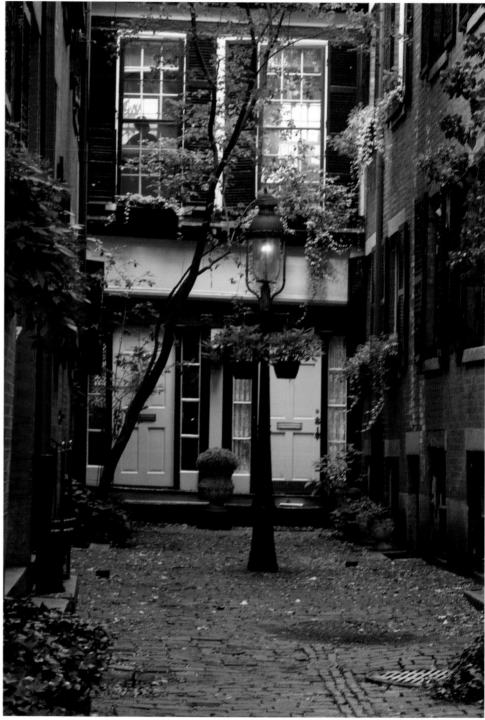

The picturesque streets and alleyways on Beacon Hill are some of the most photographed streets in America.

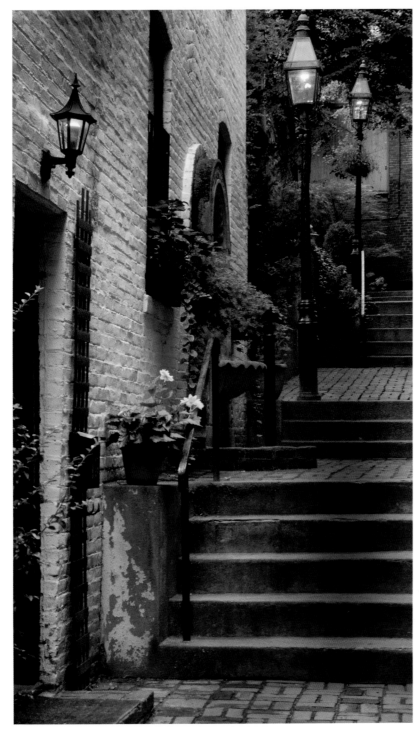

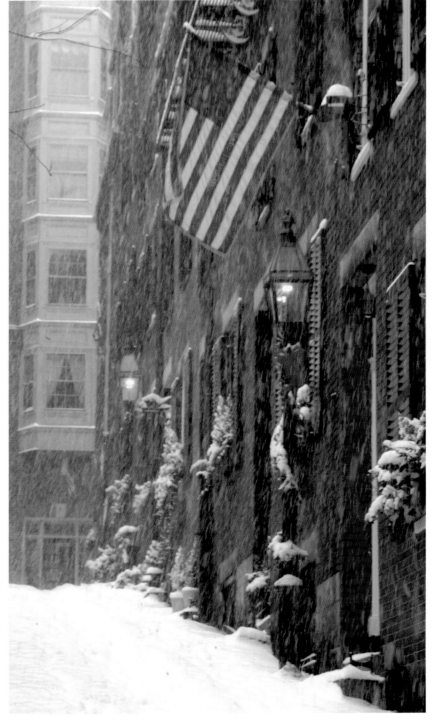

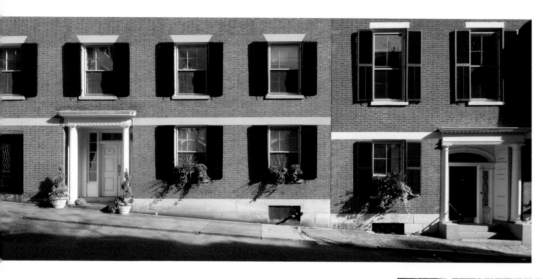

Houses on Beacon Hill are built to conform to the slope of the land. All streets and alleyways are lit with gas lamps, and some of the older streets still have cobblestones.

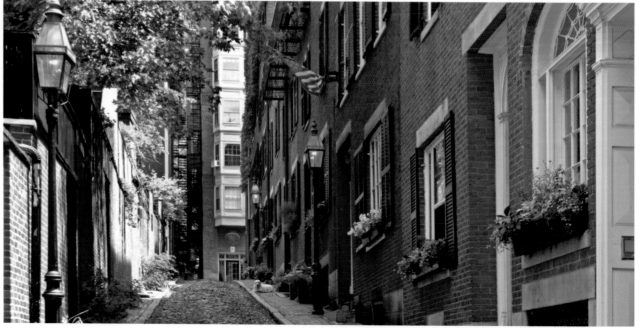

Charles Street, at the bottom of Beacon Hill, has numerous unique shops. Nearby side streets also offer charming scenic views.

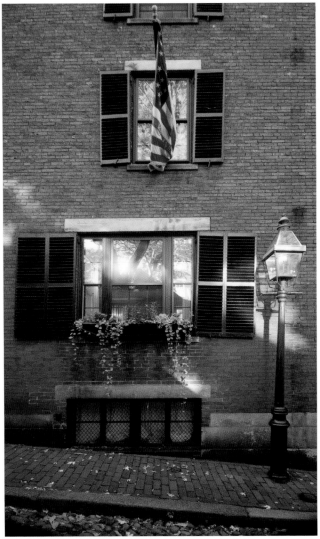

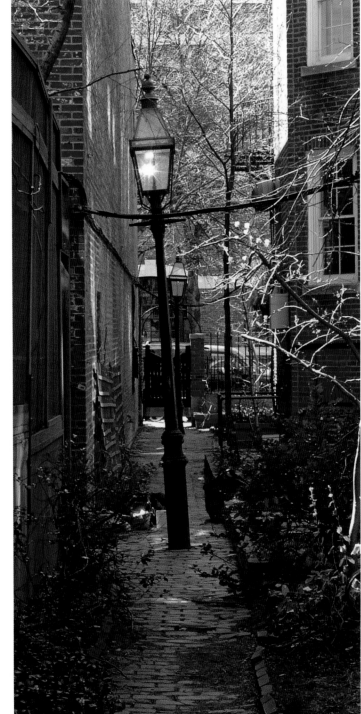

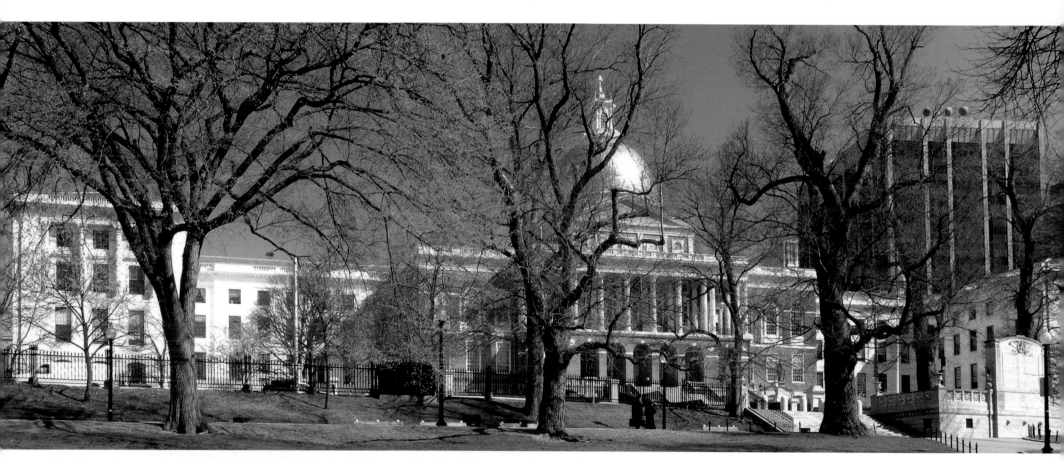

The Massachusetts State House, located on Beacon Hill, is on land once owned by John Hancock, who was the first governor of the Commonwealth. It was built in 1798 and in 1802 the dome was covered with copper by Paul Revere. The dome was gilded with gold in 1874, and is recognizable from various locations throughout the city. Facing the Boston Common, the State House is one of the first stops on the Freedom Trail.

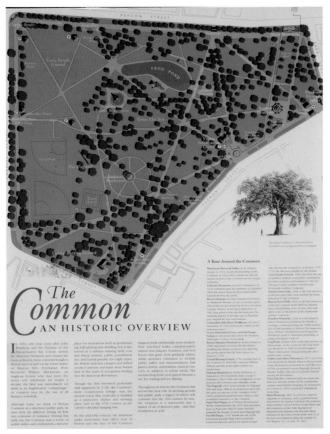

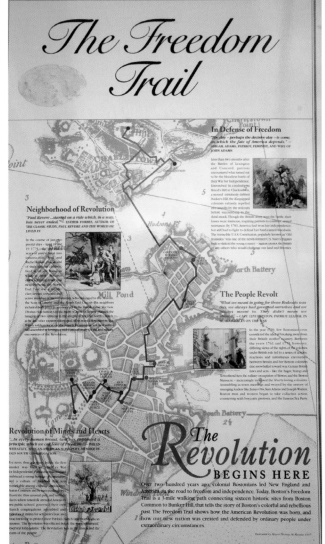

The Freedom Trail

The Common
AN HISTORIC OVERVIEW

The Boston Common, nearly 50 acres in size, is the oldest park in America and the starting point for the famous Freedom Trail. Since 1634, the land has belonged to the people of Boston, as "*..a place for training field, which ever since and now is used for that purpose and for the feeding of Cattel."* British troops camped here before the Revolution, and cattle were allowed to graze until the 1830s. Bright flowers are planted in front of the information booth that welcomes visitors.

The Revolution
BEGINS HERE

Over two-hundred years ago, colonial Bostonians led New England and America on the road to freedom and independence. Today, Boston's Freedom Trail is a 3-mile walking path connecting sixteen historic sites from Boston Common to Bunker Hill, that tells the story of Boston's colorful and rebellious past. The Freedom Trail shows how the American Revolution was born, and how our new nation was created and defended by ordinary people under extraordinary circumstances.

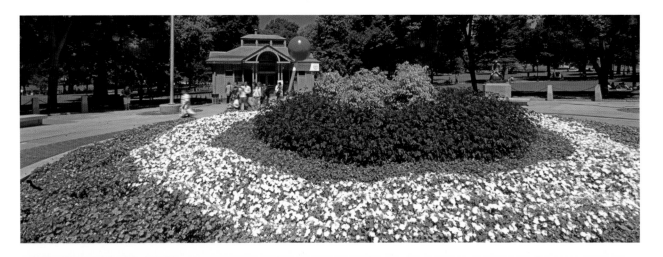

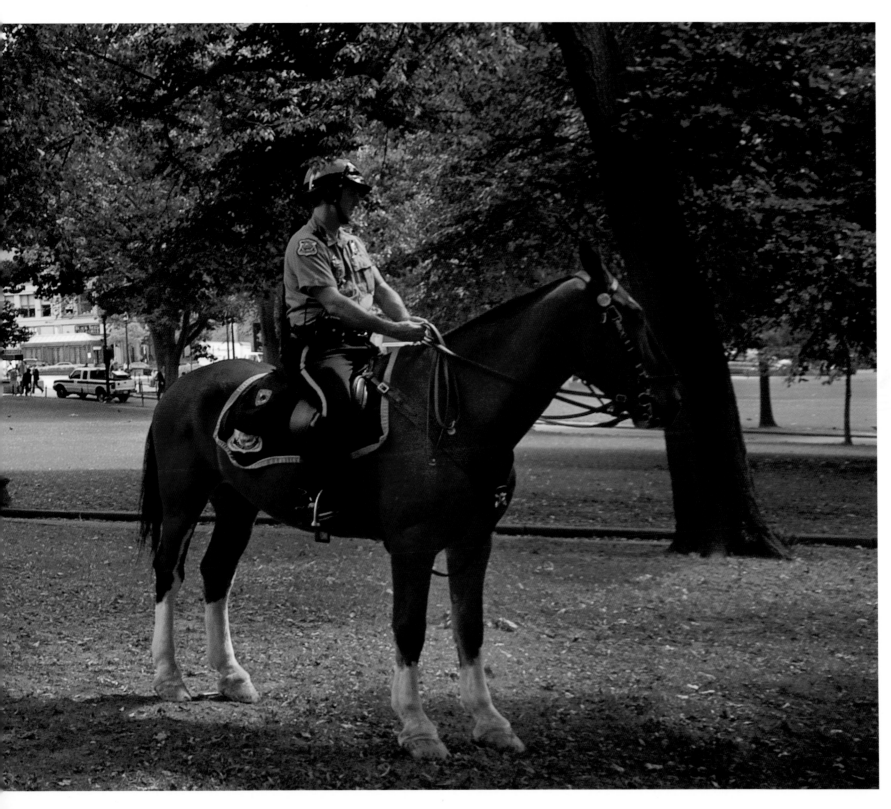

A Park Ranger
patrols the Common
on horseback.

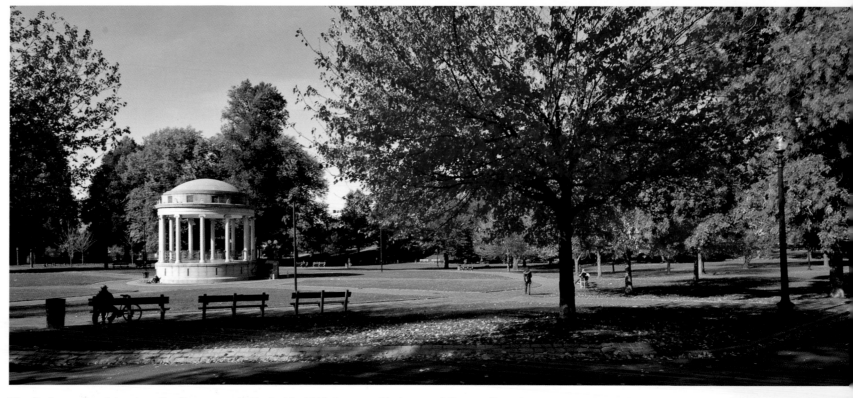

The Parkman Bandstand on the Common, dedicated in 1912, is named in honor of George Francis Parkman, Jr., who left $5 million for the care of the Common. Once the site of a pond to supply water to the cattle, it was filled in 1838, as cows no longer grazed on the Common.

On a quiet ,clear, fall afternoon, the Central Burying Ground, located at the corner of Boylston and Tremont Streets. It was bought by the city in 1756. Soldiers from the Battle of Bunker Hill and the artist Gilbert Stuart are buried here.

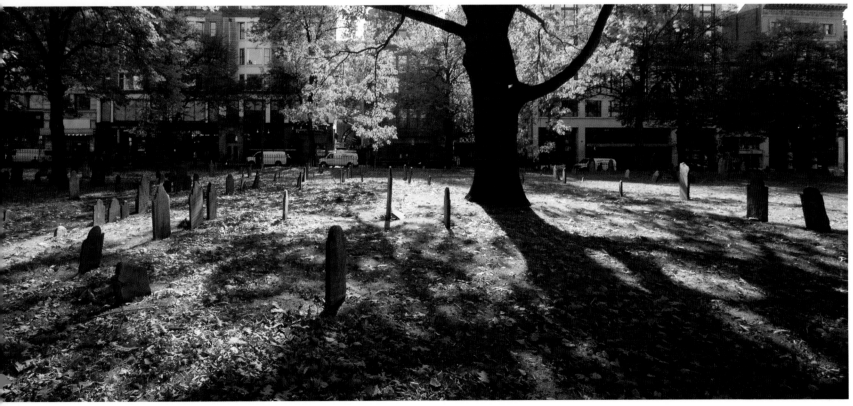

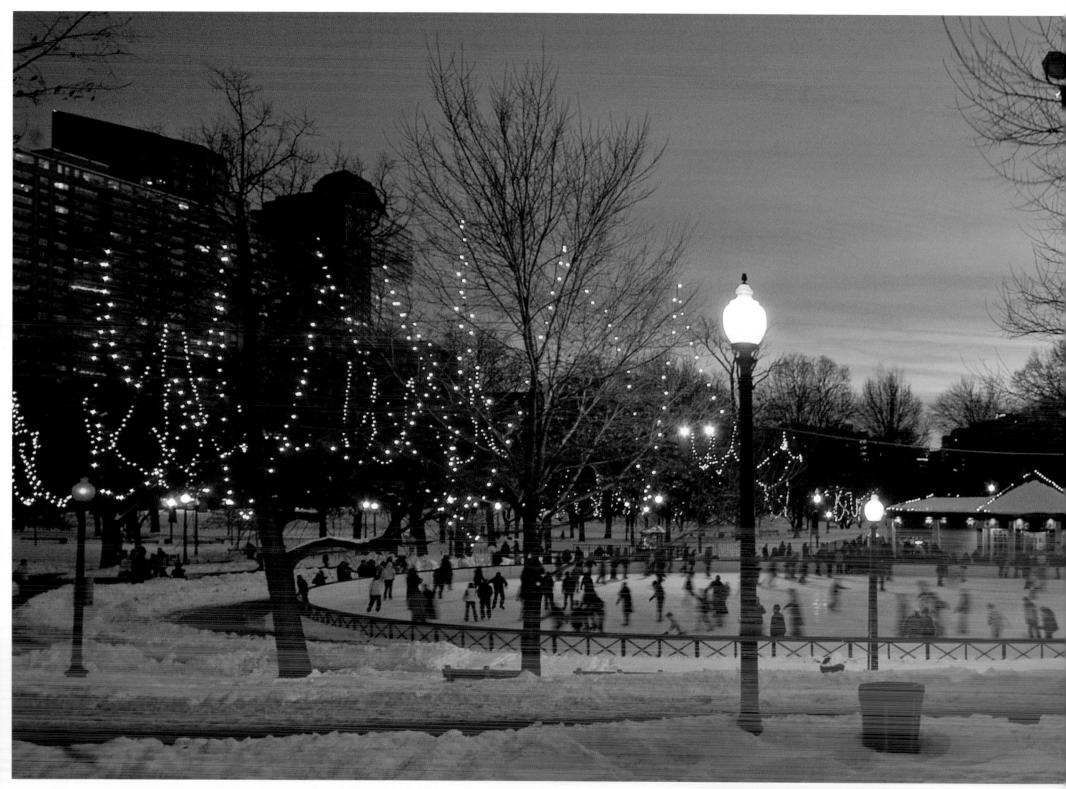

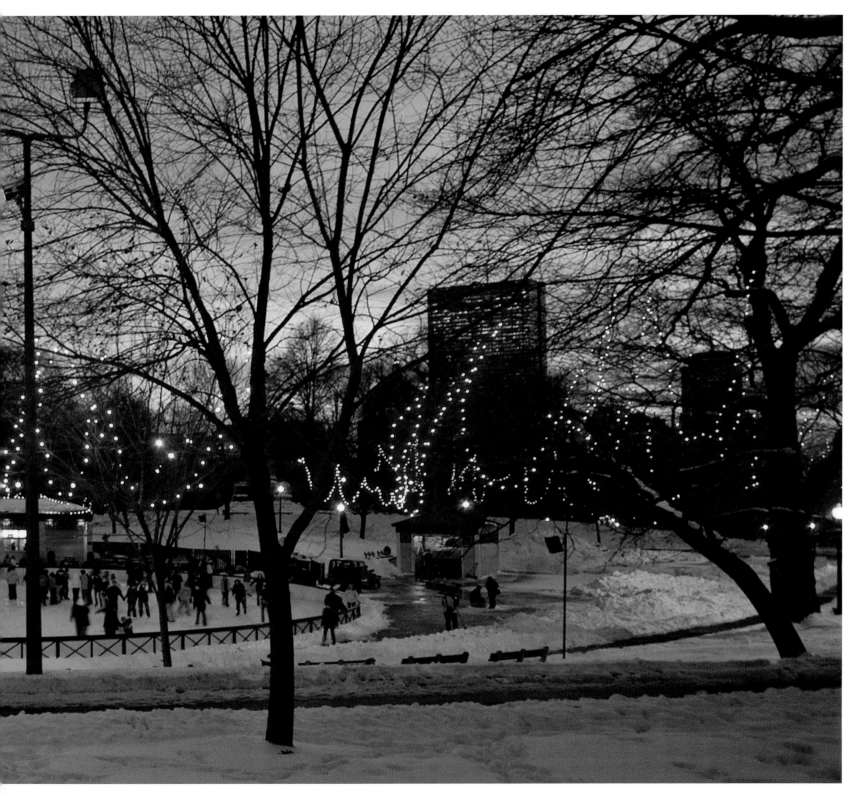

The Frog Pond, curbed in 1826, is the only pond that remains of the original three on the Common. Today, Frog Pond is a busy place as a skating pond in the winter and a wading pool in the summer. Spring and fall, the pool, with only six inches of water, is a reflecting pond and an ideal place to relax and enjoy the environs.

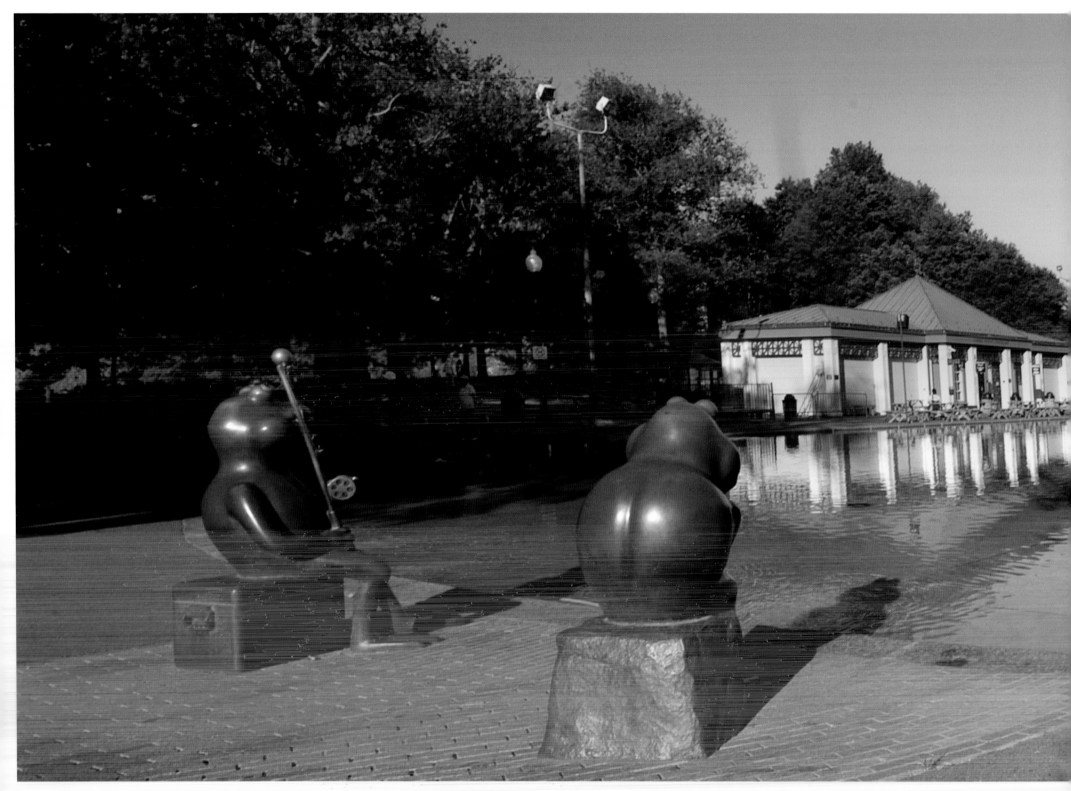

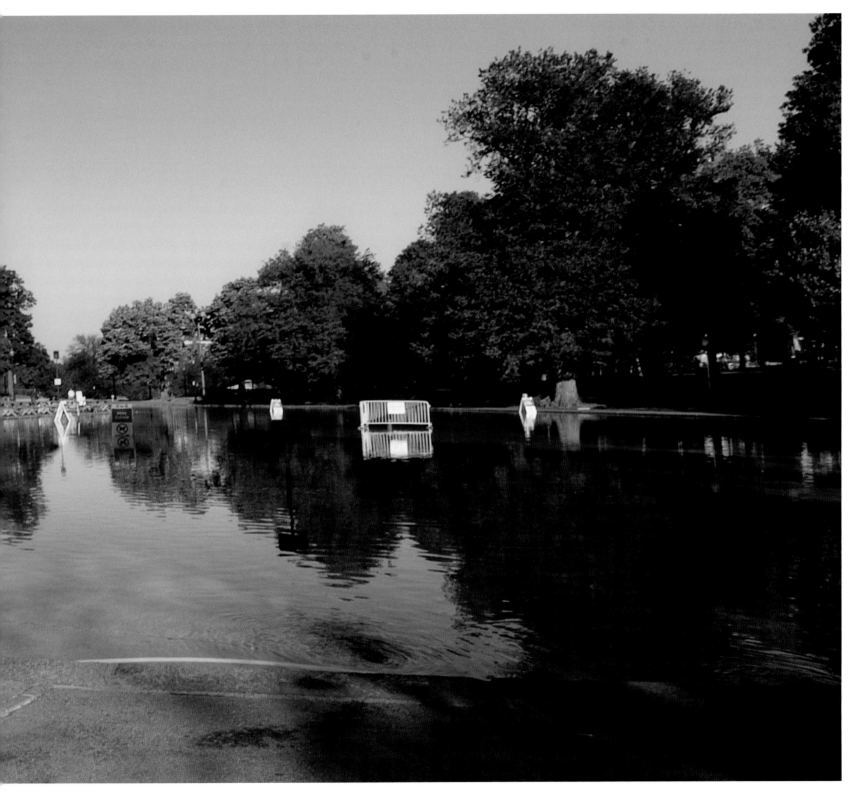

The Frog Pond was first opened on October 25, 1848, in a "Water Celebration," to inaugurate the city's public water system. The water was pumped through an aqueduct from nearby Natick, and an 80-foot fountain of water delighted the onlookers. A recent survey has shown that more than half the people using the Frog Pond are visitors to Boston.

This statue of George Washington welcomes visitors to the Boston Garden entering from Arlington Street. Created by Thomas Ball in 1869, and unveiled on the 4th of July, this was the first statue to show our first President astride a horse. It was built after the Civil War when the nation was looking for peace and unity and had turned to the founding fathers for their strength and conviction.

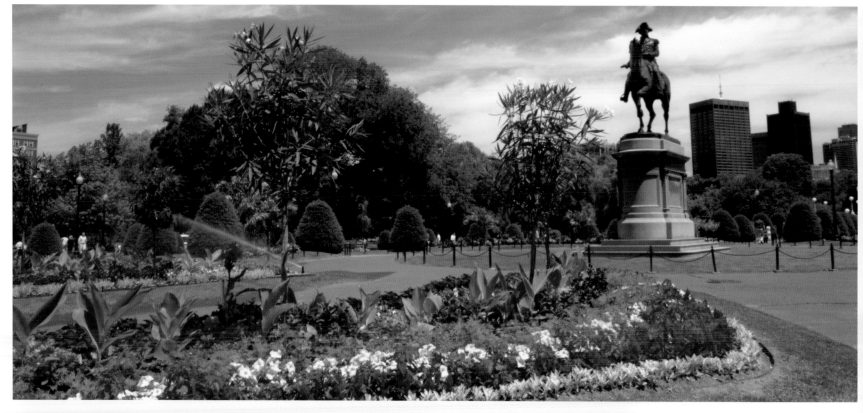

Benches and shaded walkways on the Boston Garden afford visitors a quiet oasis.

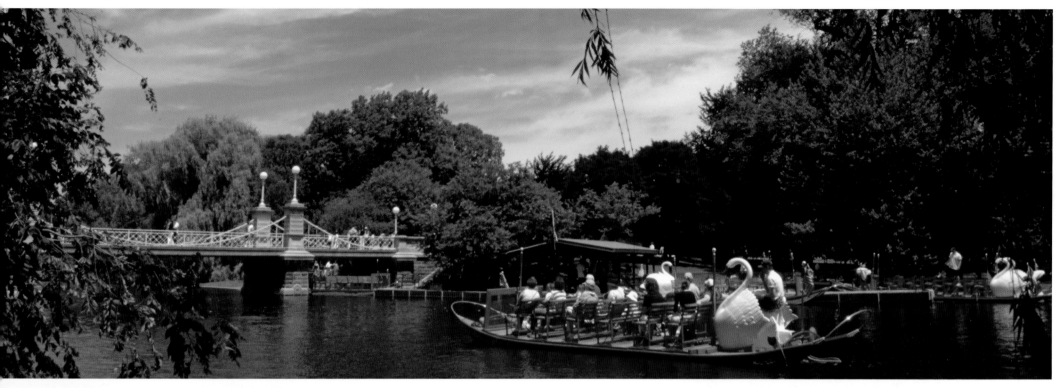

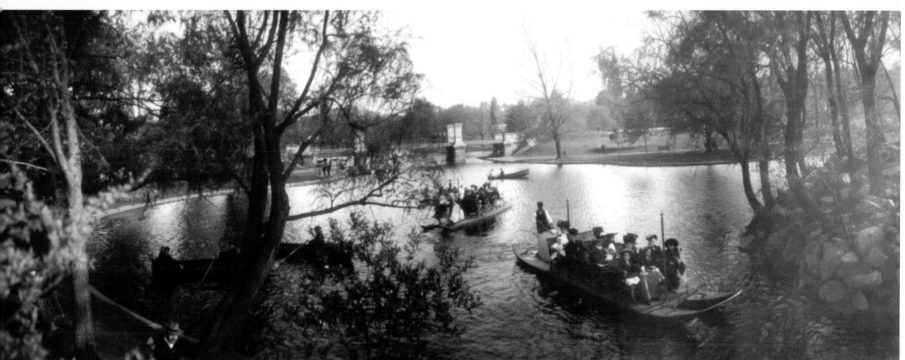

Since 1877, the Swan Boats have provided visitors with a leisurely ride on the lagoon in the Boston Garden. A cultural icon, the boats operate from April to October. The second image, from the early 1900s, shows the lagoon, which even then was a favorite subject for panoramic photographers. (Courtesy of Library of Congress).

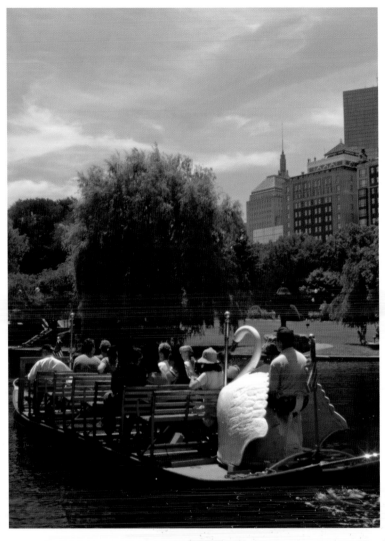

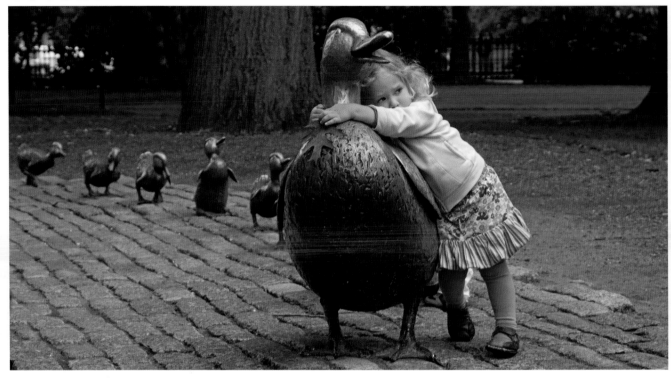

The *Make Way for Ducklings* statues found on Boston Garden are a favorite of children. They are taken from a 1941 book of the same name, written and illustrated by Robert McCloskey, that tells the story of a pair of mallard ducks that raise a family of eight ducklings on the lagoon in the Boston Garden. Jack, Kack, Lack, Mack, Nack, Ouack, Pack, and Quack are the ducklings facing the problems of growing up. The story is popular worldwide, and similar small statues can be found in Novodevichy Park in Moscow, Russia.

Pedal-power provides power to the Swan Boats for the 15-20 minute ride that circles the lagoon and passes under the ornamental bridge, built in 1869. The paddles are hidden behind the swans.

Overshadowed by the nearby towers of the financial district, the Old State House was, from 1713 to 1776, the seat of the British government in Boston. It then became the Massachusetts State House until 1798, when the present day State House was completed.

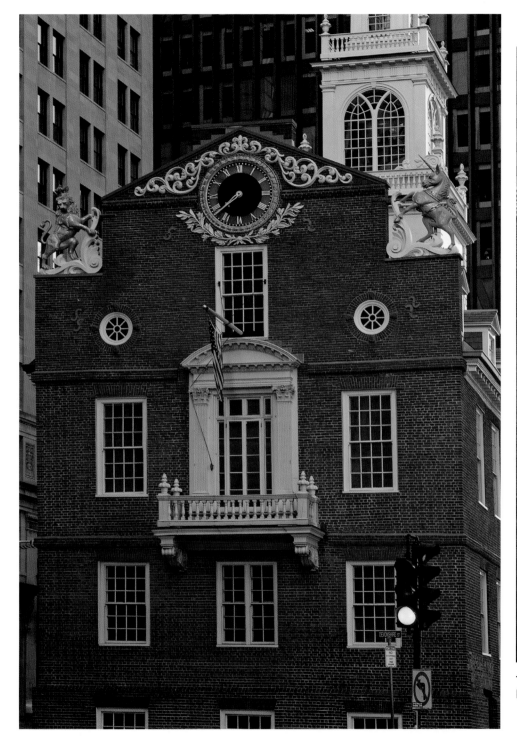

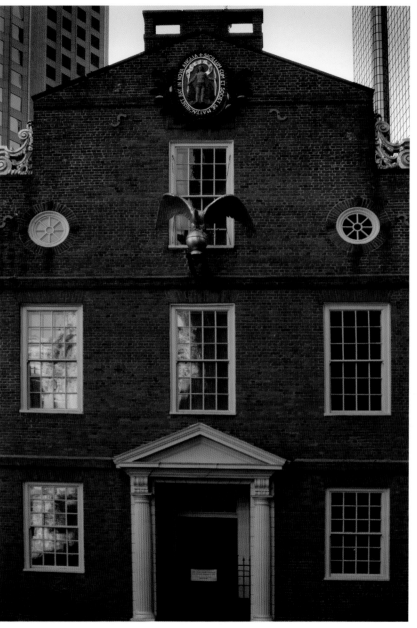

The west façade, with a gold eagle sculpture and a crest of the first Massachusetts Bay Colony, with a Native American in the center.

The east façade with the balcony from where the Declaration of Independence was read to the public in 1776. With restoration, a lion and unicorn stand on the corners of the roofline as symbols of the British Empire.

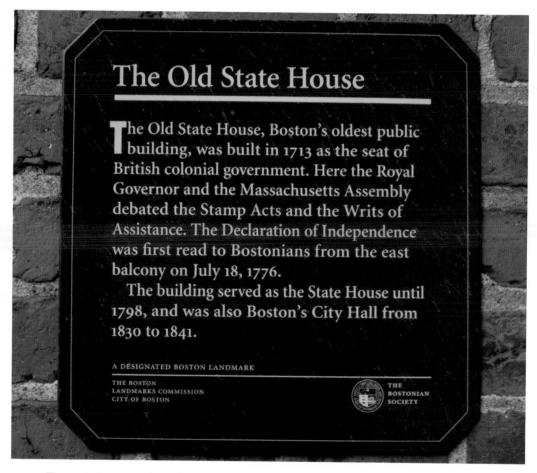

The Old State House

The Old State House, Boston's oldest public building, was built in 1713 as the seat of British colonial government. Here the Royal Governor and the Massachusetts Assembly debated the Stamp Acts and the Writs of Assistance. The Declaration of Independence was first read to Bostonians from the east balcony on July 18, 1776.

The building served as the State House until 1798, and was also Boston's City Hall from 1830 to 1841.

A DESIGNATED BOSTON LANDMARK

THE BOSTON
LANDMARKS COMMISSION
CITY OF BOSTON

THE
BOSTONIAN
SOCIETY

Through the years there have been many occupants, but the Old State House is now a museum with memorabilia dating back to before the Revolution.

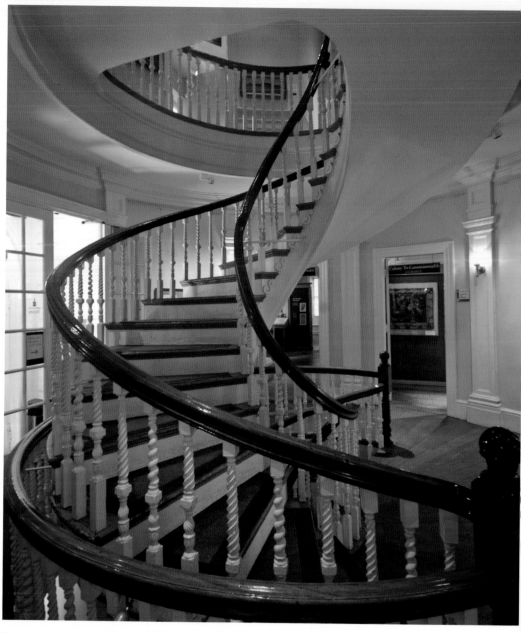

The central spiral staircase, with two crafted wooden handrails, is an excellent example of 18th century workmanship.

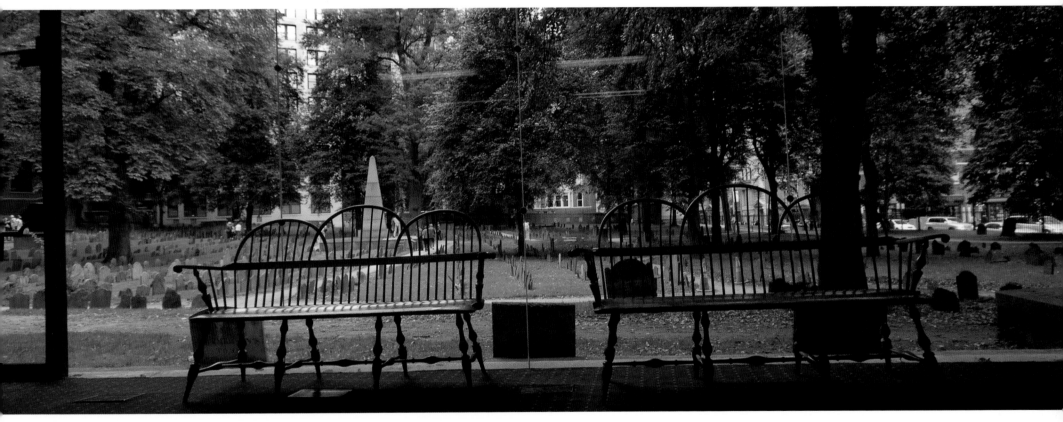

This image of the Granary Burying Ground was shot from inside the reception room of the Park Street Church. Originally established in 1660, the cemetery was given its present name in 1737, when a small building to store grain was located on what is now the Park Street Church grounds. There have been no burials since 1880. There are 2,345 gravestones and tombs, although it is estimated that more than 5,000 people are buried here. Notable people buried here include John Hancock, Samuel Adams, Paul Revere, and five victims of the Boston Massacre. Also, Mother Goose, the writer of fairy tales and nursery rhymes, has a distinctive and frequently visited gravestone in the burying ground. The 25-foot obelisk seen in the background commemorates the parents of Benjamin Franklin.

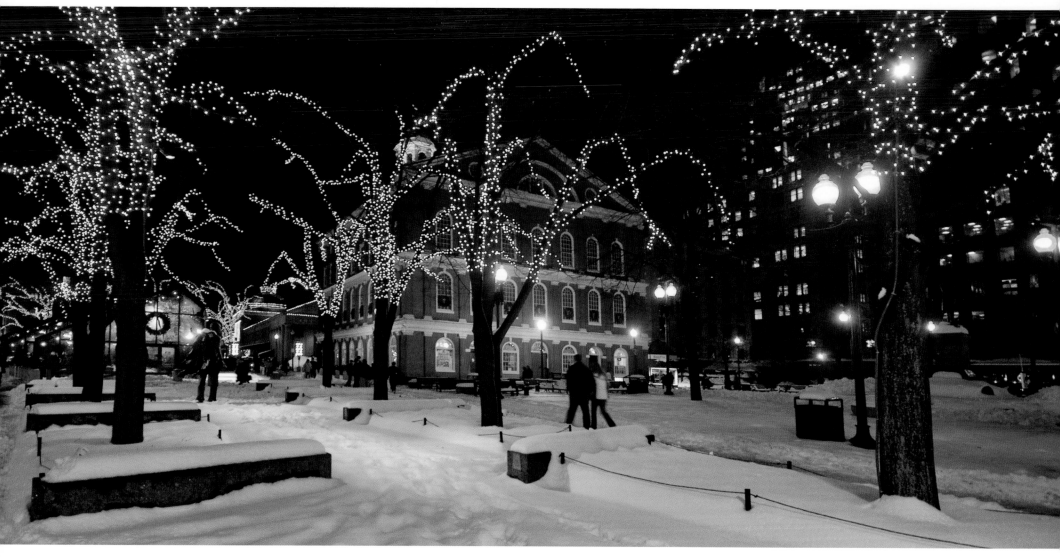

Faneuil Hall, also known as the "Cradle of Liberty," has been a meeting place and market since 1742. Many significant historical events have taken place here.

A coating of snow and bright holiday lights emphasize the allure of Faneuil Hall and Quincy Market.

Quincy Market, dating from 1825, and originally part of Faneuil Hall, was renovated in the 1970s, and is now a popular dining and shopping area.

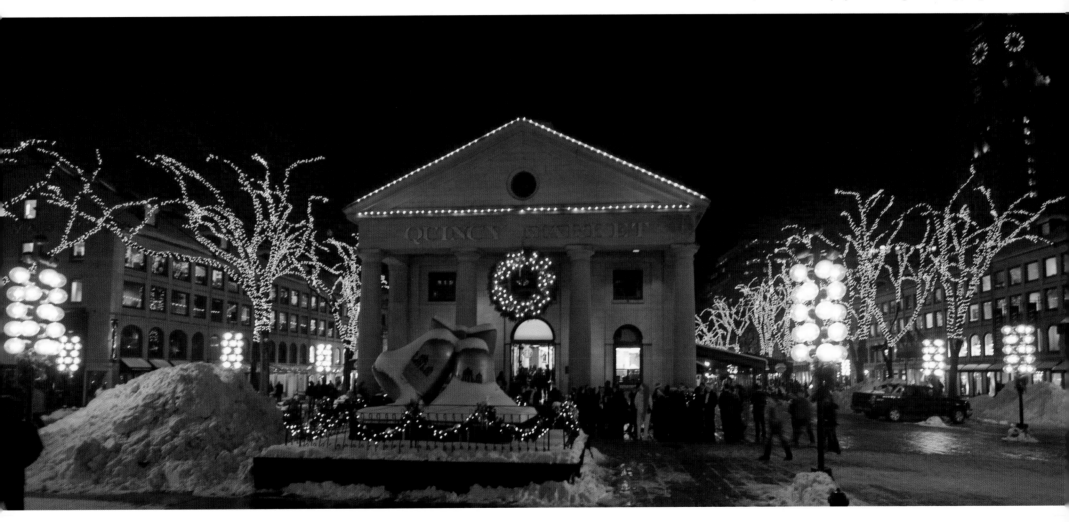

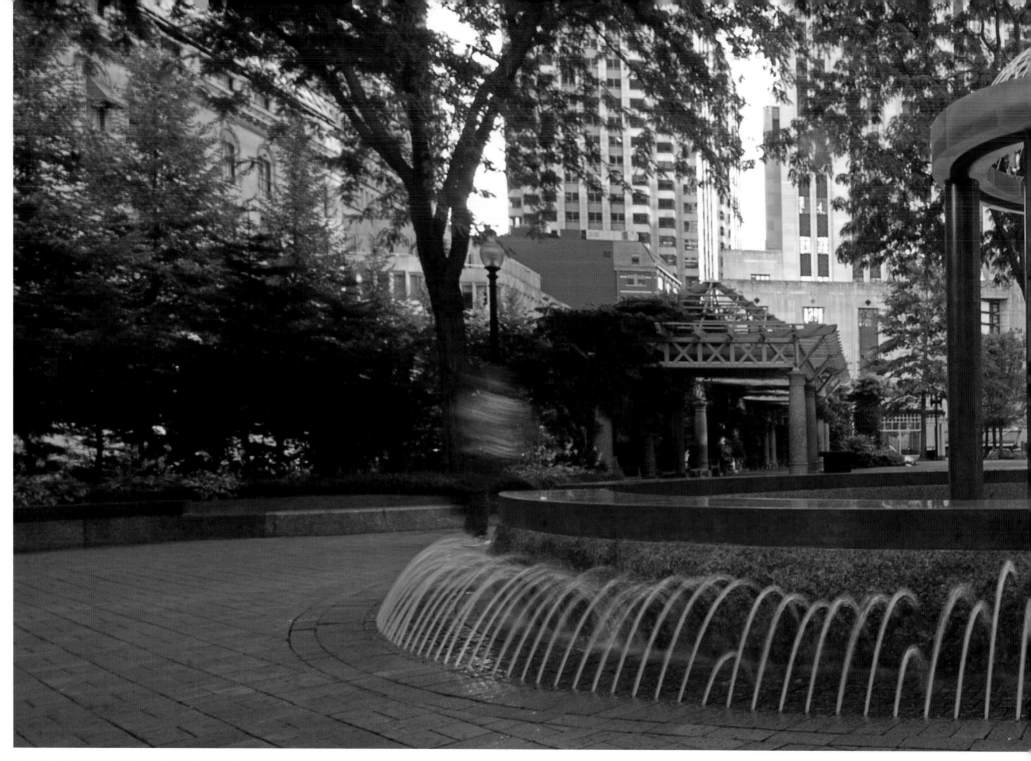

A park in Post Office Square in early morning.

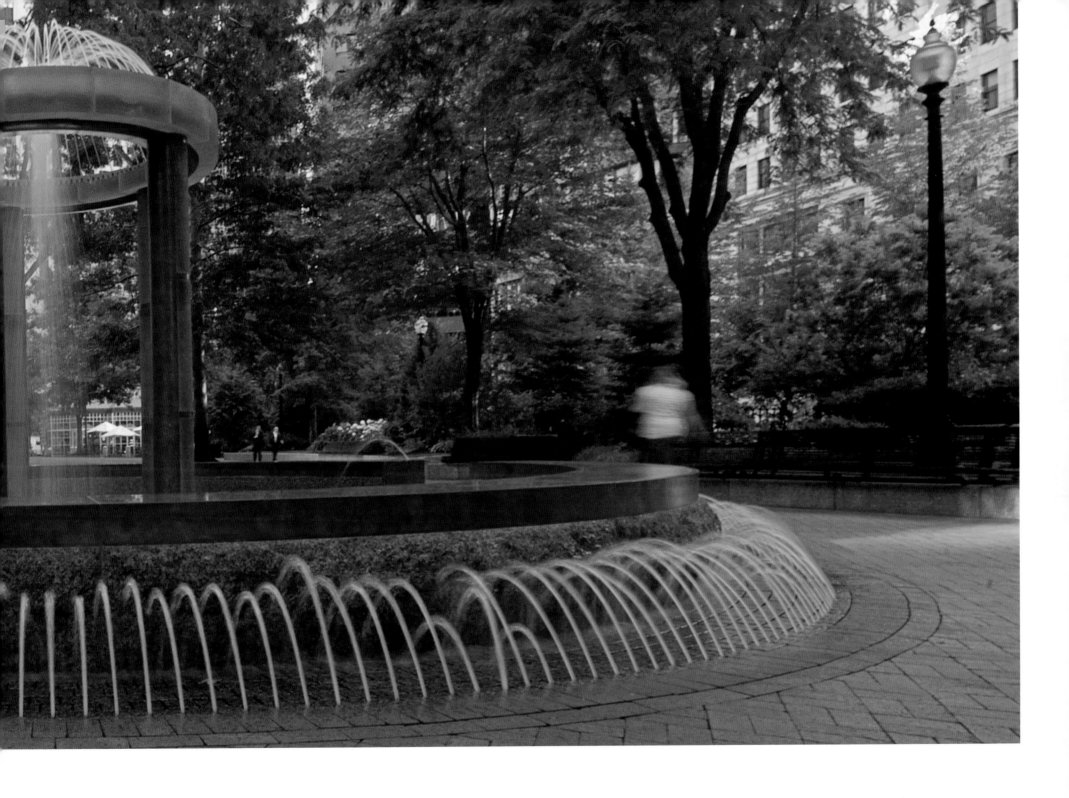

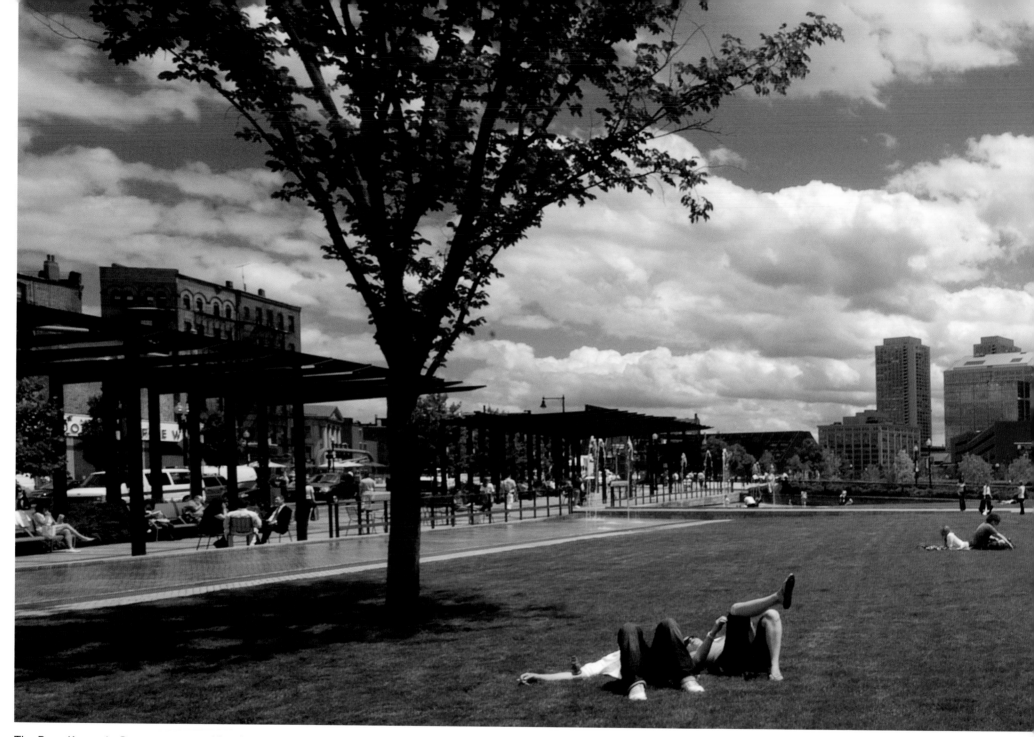

The Rose Kennedy Greenway, named for the mother of President John F. Kennedy, consists of 15 acres of land which was added to the city's parks when the Big Dig moved the elevated roadways to underground. This view, near the North End, is looking south with the distinctive Custom House along the skyline in the center.

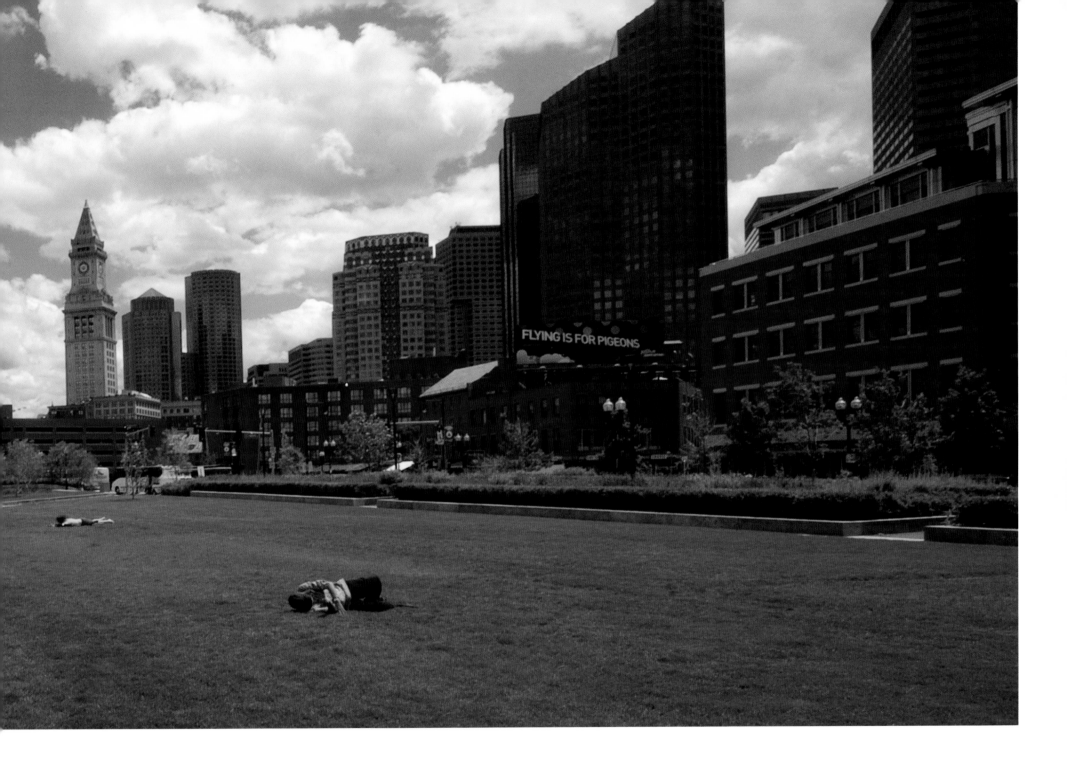

With benches and walkways, the Greenway provides a peaceful area within the city.

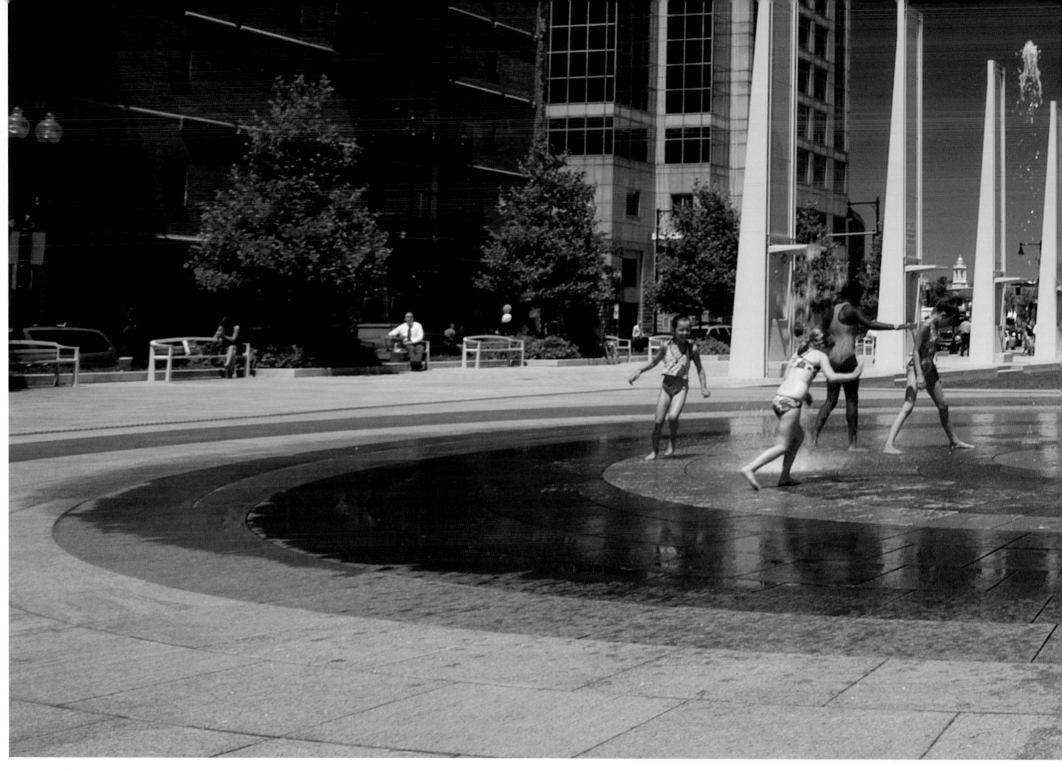

Oscillating fountains along the Greenway provide a cooling experience for youngsters.

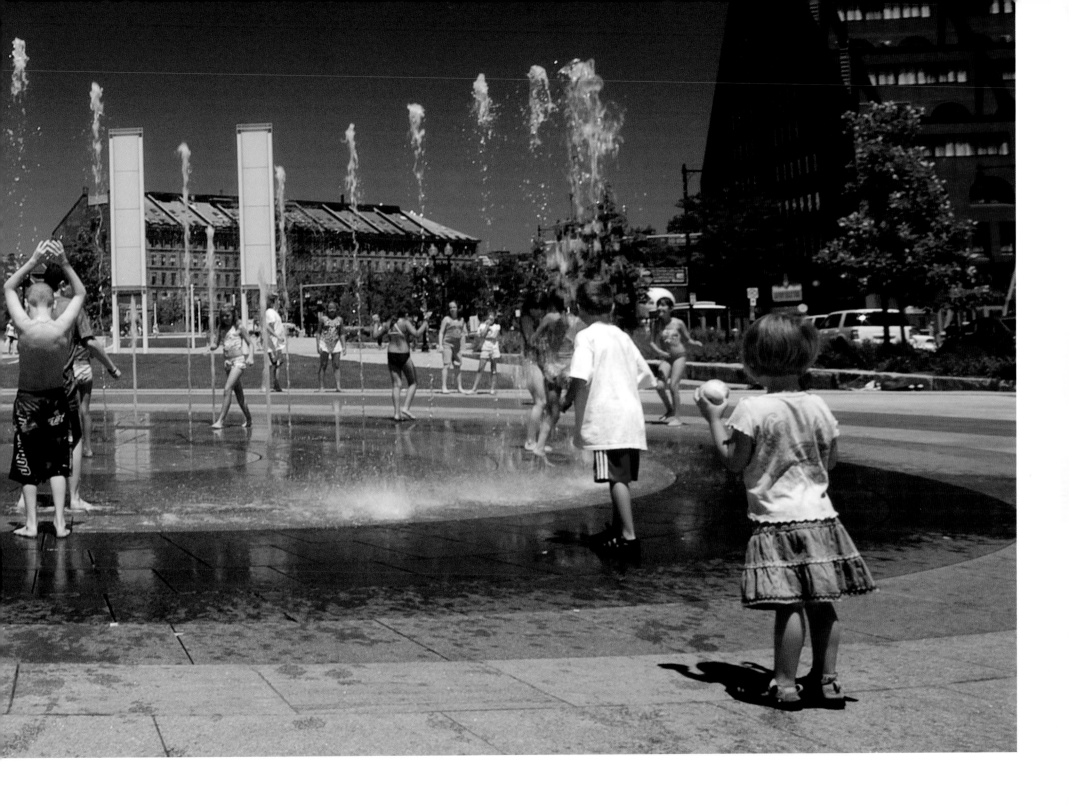

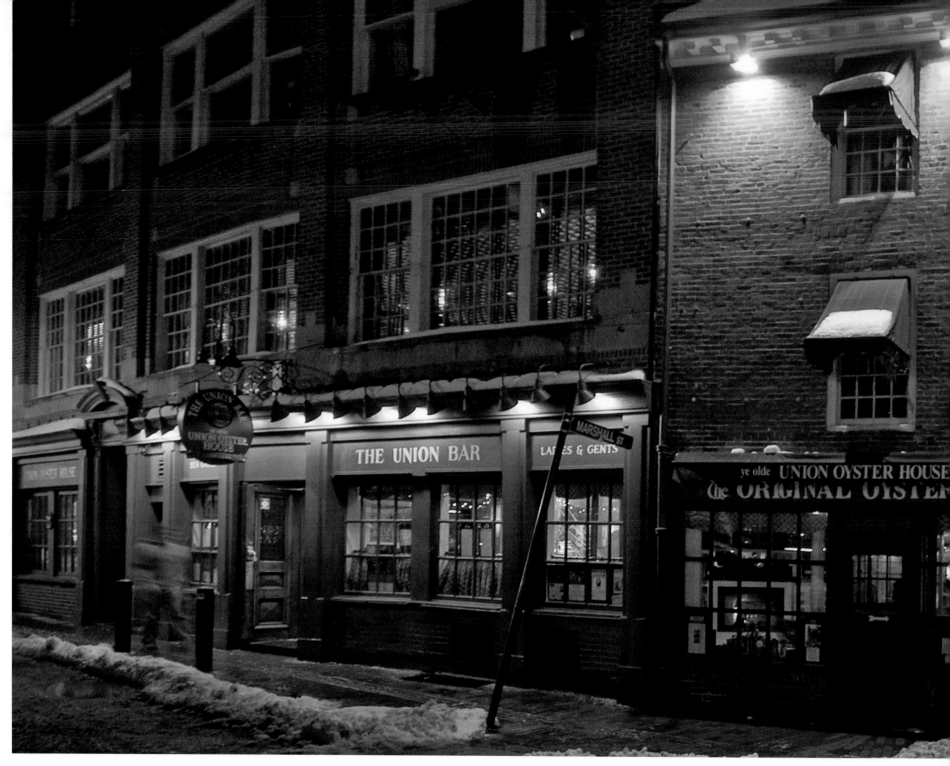

The Union Oyster House, built more than 250 years ago, is the oldest restaurant in the United States, with continuous service since 1826.

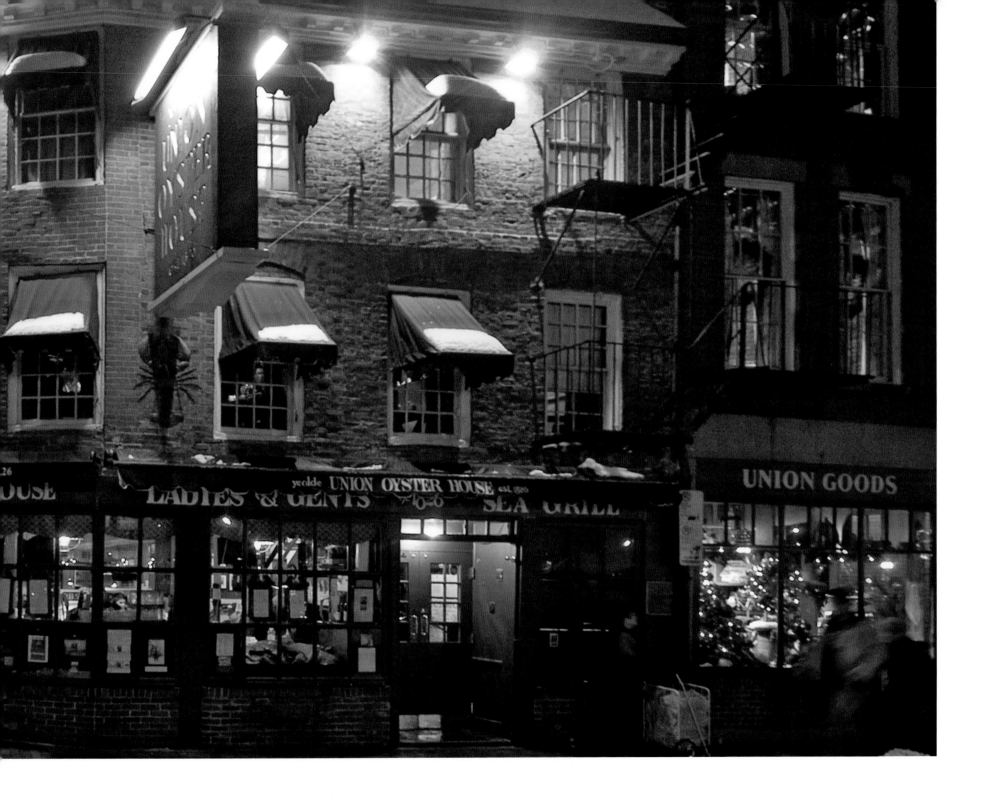

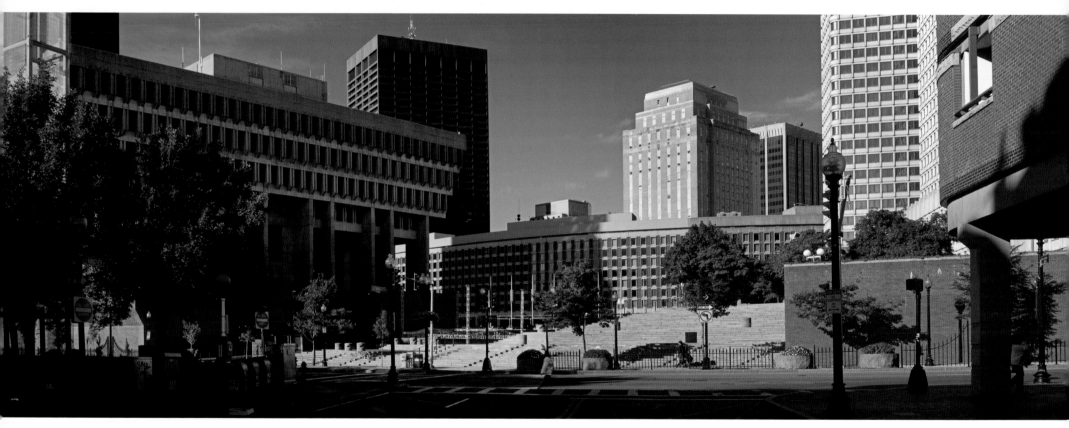

City Hall Plaza

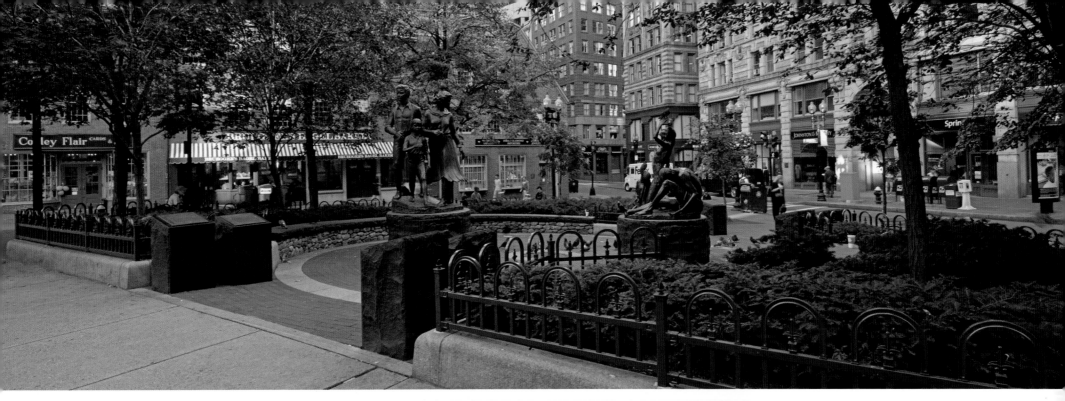

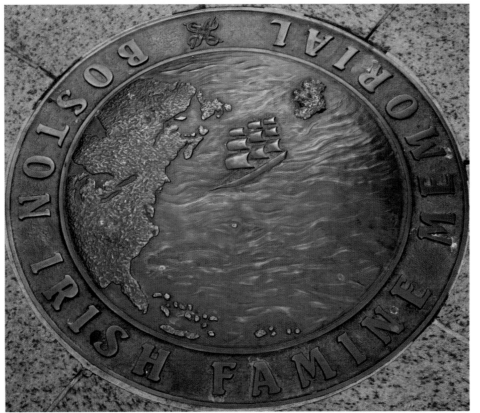

The Boston Irish Famine Memorial, located at the corner of Washington and School Streets, was unveiled on June 28, 1998. It commemorates the 150th anniversary of the Irish famine which killed over 1 million people, and is one of the stops on the Boston Irish Heritage Trail. In the center background, at the intersection of the two streets, is the Old Corner Bookstore, which is one of the stops on the Freedom Trail. Originally built as an apothecary in 1718, it became the Old Corner Bookstore in 1829 and later a publishing house. It was the gathering place of such authors as Emerson, Thoreau, Longfellow, and Hawthorne. The *Atlantic Monthly* was first published here.

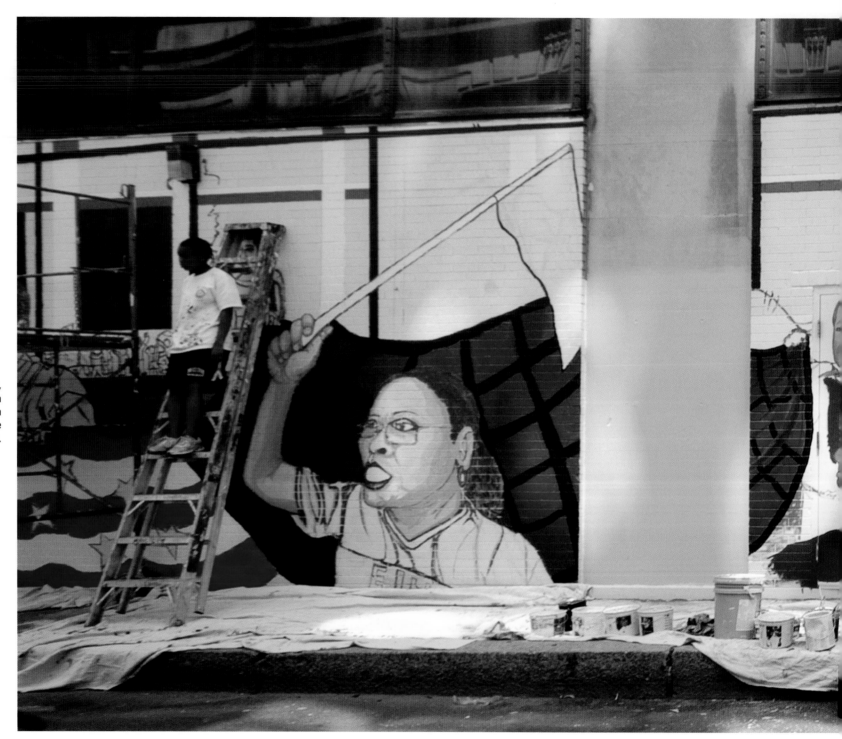

During the summer months, students from Boston high schools paint murals on the walls of buildings in the downtown area.

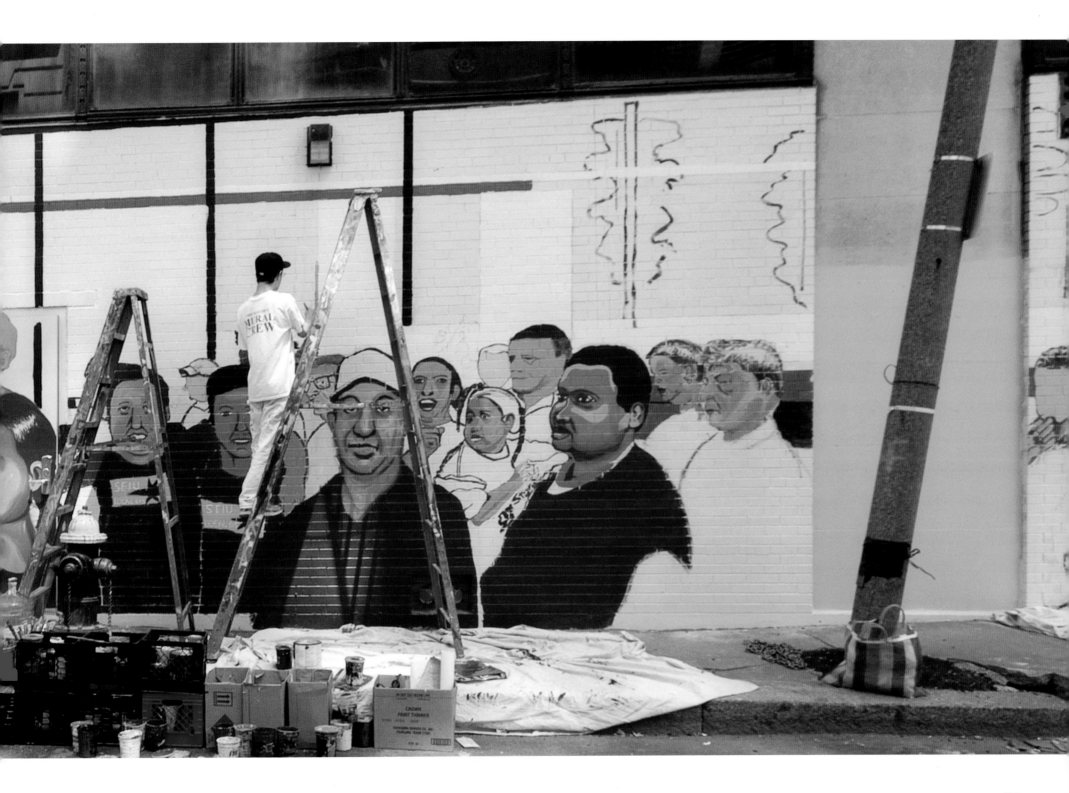

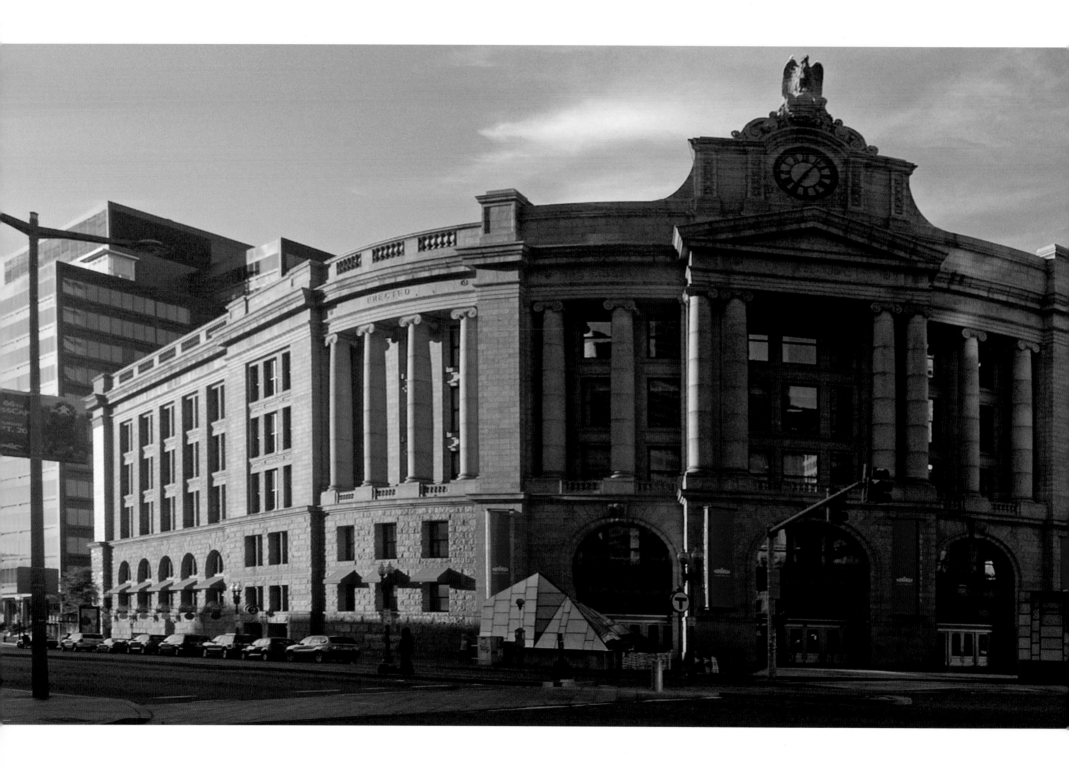

South Station on Atlantic Avenue was opened on January 1, 1899, with four terminals serving four different railroads. By 1910, it was the busiest train station in America and, in 1978, was designated on the National Register of Historic Places. It is still active as the northern terminus for high speed trains, local commuter rails, and bus service.

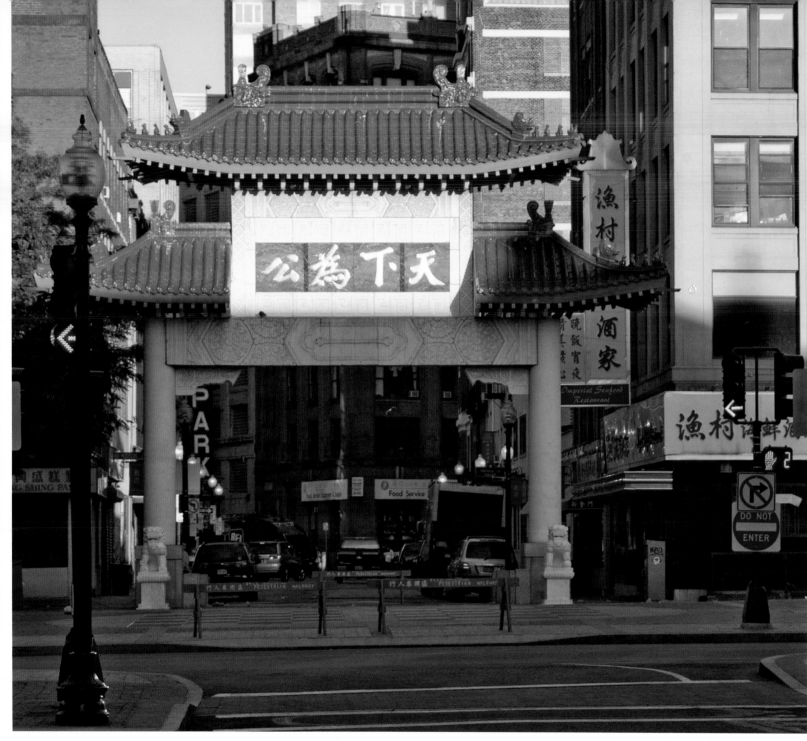

A paifang welcomes visitors to the only historically Chinese area in New England, located in downtown Boston. Chinatown is still the center of Asian-American life and has numerous Chinese, Vietnamese, Cambodian, and Japanese restaurants.

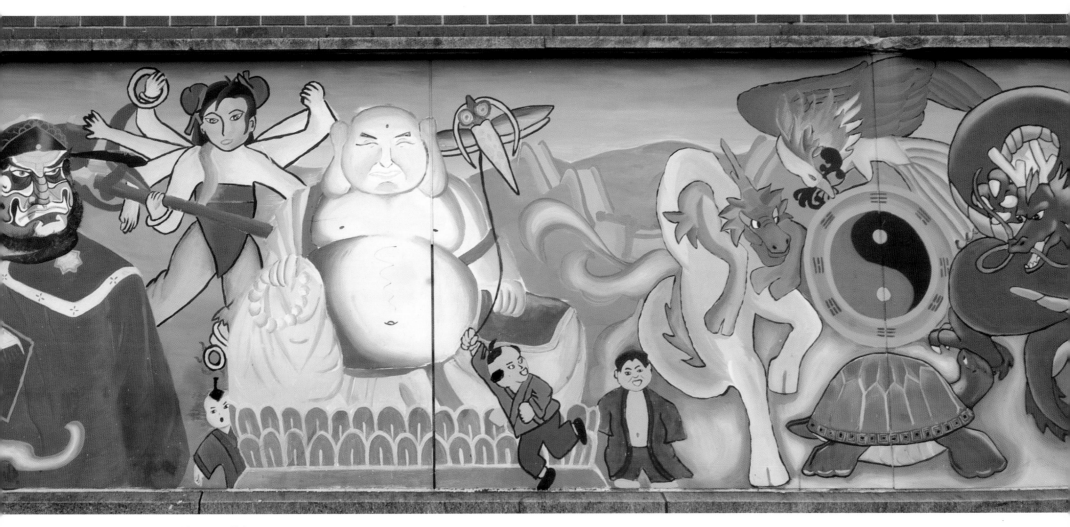

A wall mural welcomes visitors to Chinatown.

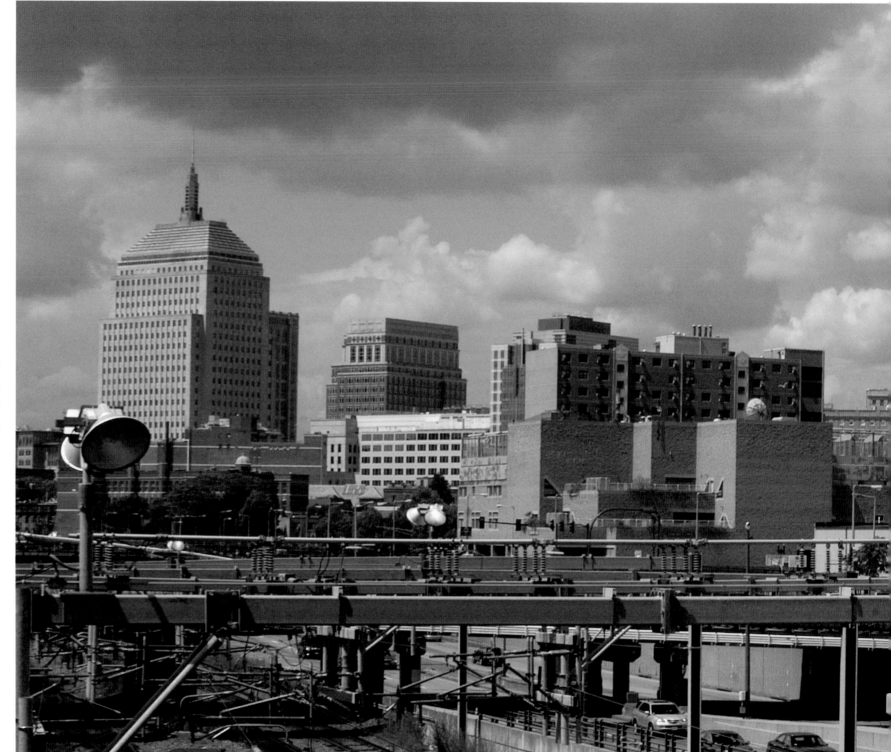

With the Mass Pike in the foreground, the skyline of Boston looking north towards Chinatown on the right and the Theater District on the left.

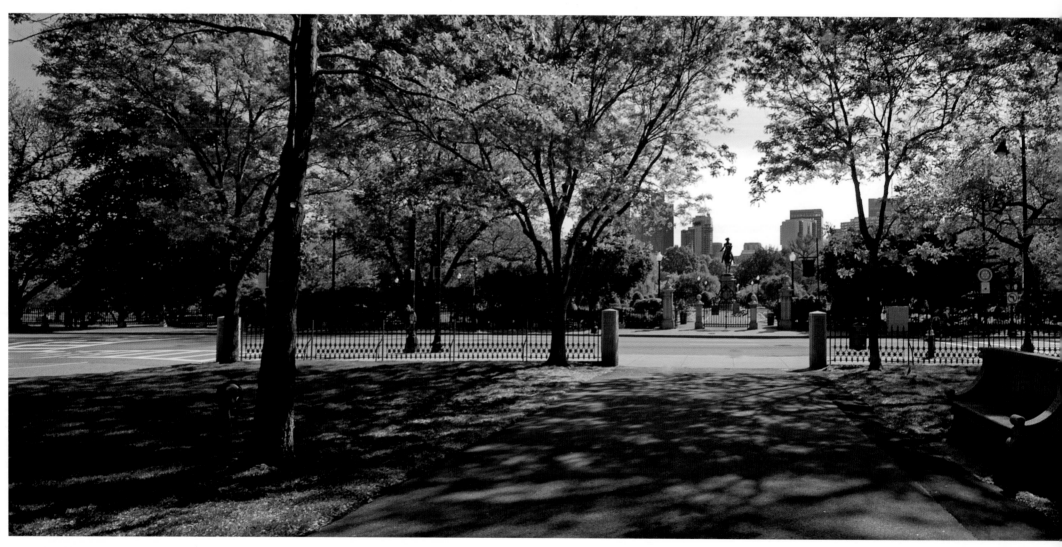

Looking towards the Boston Garden and the starting point of the Mall.

Established in 1856, Commonwealth Avenue Mall, connecting Boston to the Back Bay, is 32 acres designed in the French boulevard style. It is part of the Emerald Necklace, which created the green link in Frederick Law Olmstead's park system. The central promenade is decorated with monuments and dignified plantings that are maintained by a citizen's advocacy group.

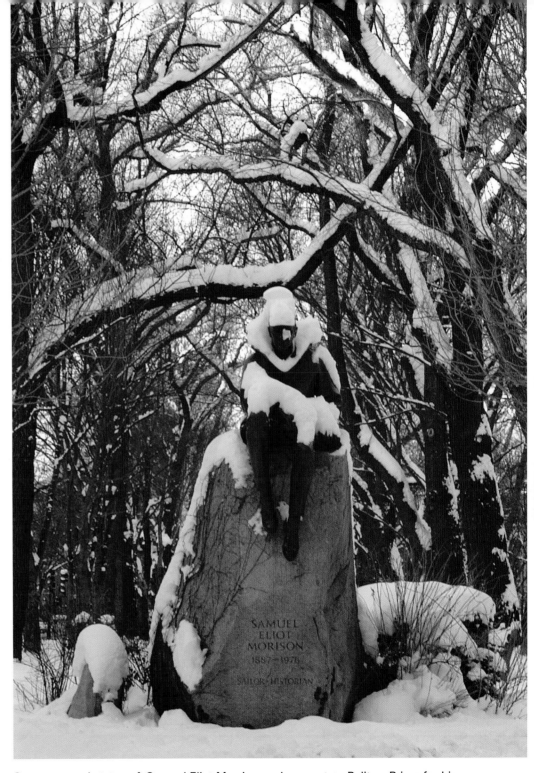

Snow covered statue of, Samuel Eliot Morrison, who won two Pulitzer Prizes for his books on maritime history. He also sailed the Atlantic and retraced one of Christopher Columbus's voyages using the original log books.

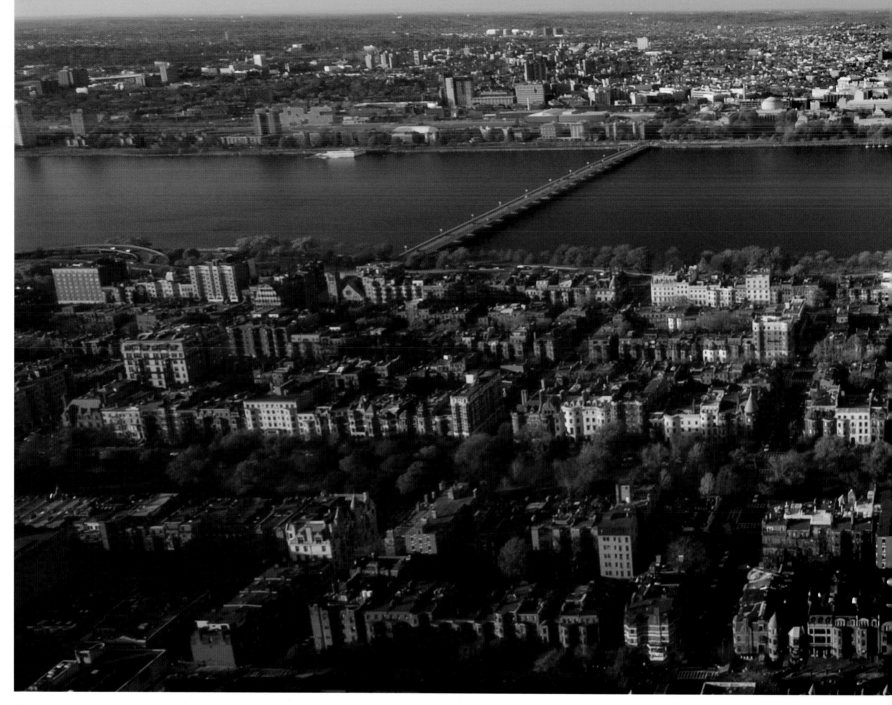

One of the best places to see spectacular 360 degree views of Boston is the Prudential Skywalk Observatory, located on the 50th floor. Not only are fantastic sights afforded of Copley Square, Charles River, and Fenway Park, but on a clear day the beaches of Cape Cod and the mountains of New Hampshire can be seen. This view, looking north across Back Bay, shows the treed Commonwealth Avenue Mall, and the Charles River, with the Esplanade in the center. The Mass Avenue Bridge is on the left, and the Longfellow Bridge is on the right. Cambridge is on the far side of the Charles River.

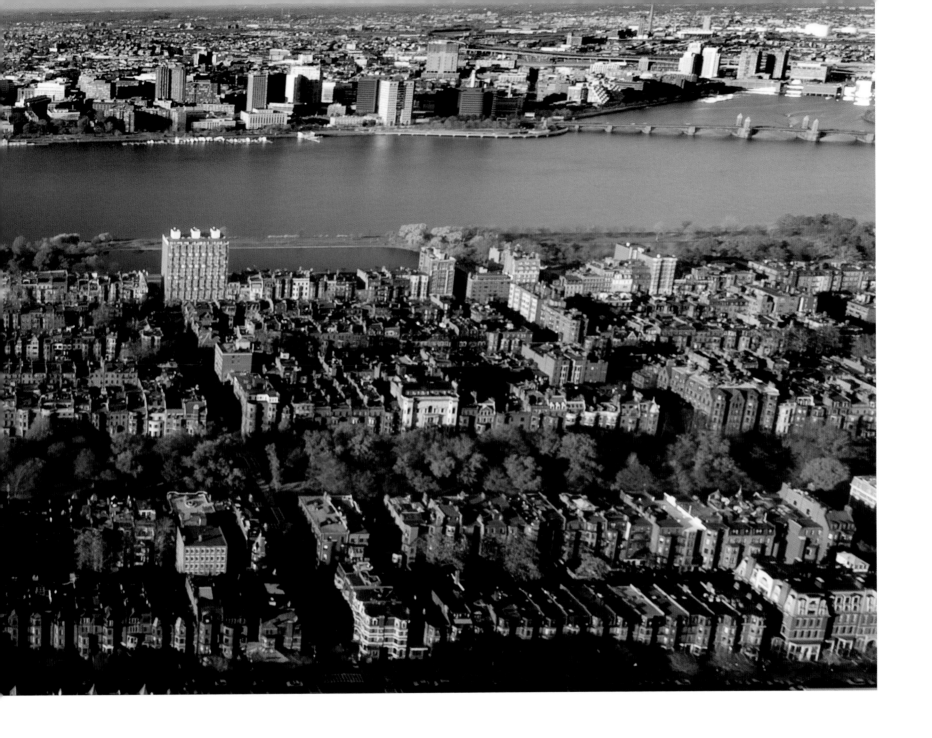

Abigail Adams, the wife of John Quincy Adams, the second President of the United States, wrote to her husband on March 31, 1776, *"...and by the way in the new Code of Laws which I suppose it will be necessary for you to make I desire you would Remember the Ladies, and be more generous and favorable than your ancestors. Do not put such unlimited power in the hands o f the Husbands. Remember all Men would be tyrants if they could. If particular care and attention is not paid to the Ladies we are determined to foment a Rebellion, and will not hold ourselves bound by any Laws in which we have no voice, or Representation."*

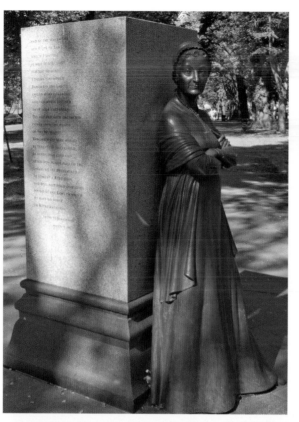

The Boston Women's Memorial, dedicated on October 25, 2003, celebrates three women—Abigail Adams, Lucy Stone, and Phillis Wheatley—who had progressive ideas that contributed to social change and had a significant impact on the history of Boston. Unlike other memorials that are larger than life, each woman is sculpted to reflect her manner of life so that the observer is invited to interact with them.

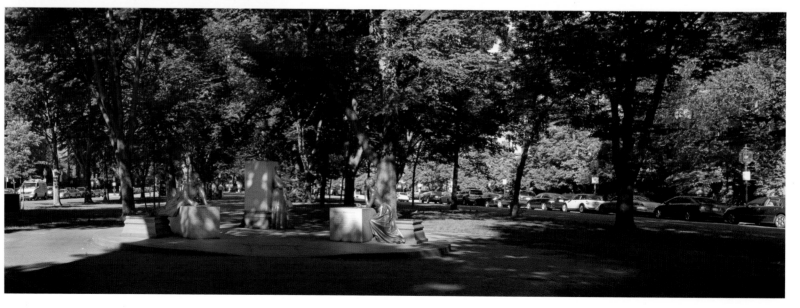

Near Beacon Hill and Back Bay on the Boston side of the Charles River, a series of walkways, islands and lagoons are collectively known as the Esplanade. The area offers visitors numerous activities, including walking, biking, and boating.

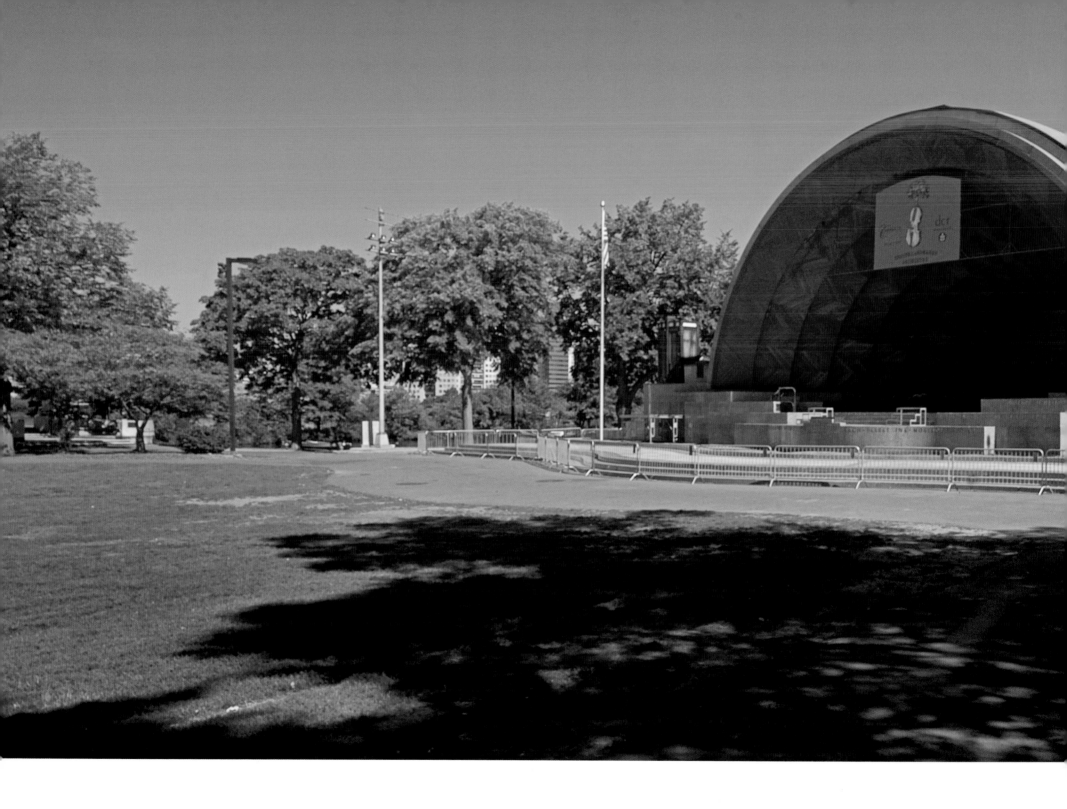

With over two acres, the Hatch Memorial Shell provides a venue for outdoor concerts. Built in 1939, the shell has been made famous by Arthur Feidler, former conductor of the Boston Pops Orchestra, who performed every year on the 4th of July to an audience of over 500,000 spectators. The tradition continues and Tchaikovsky's "1812 Overture," with live cannon fire and fireworks, highlights the celebration.

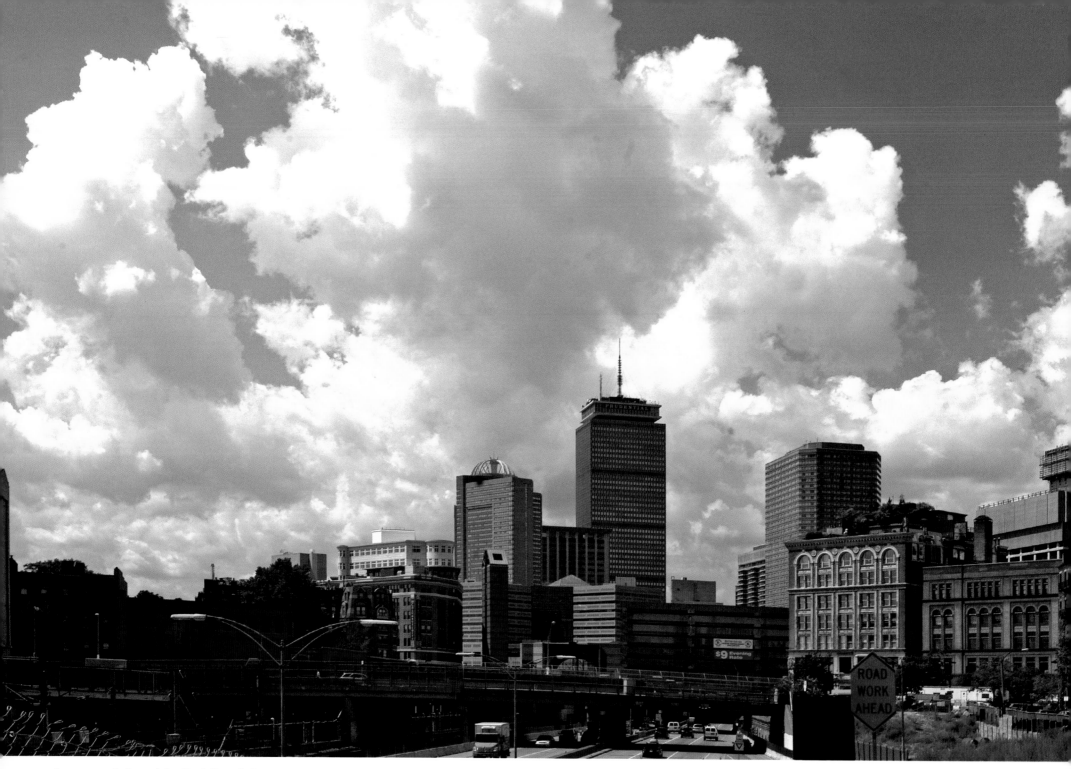

A westward view of the Back Bay skyline

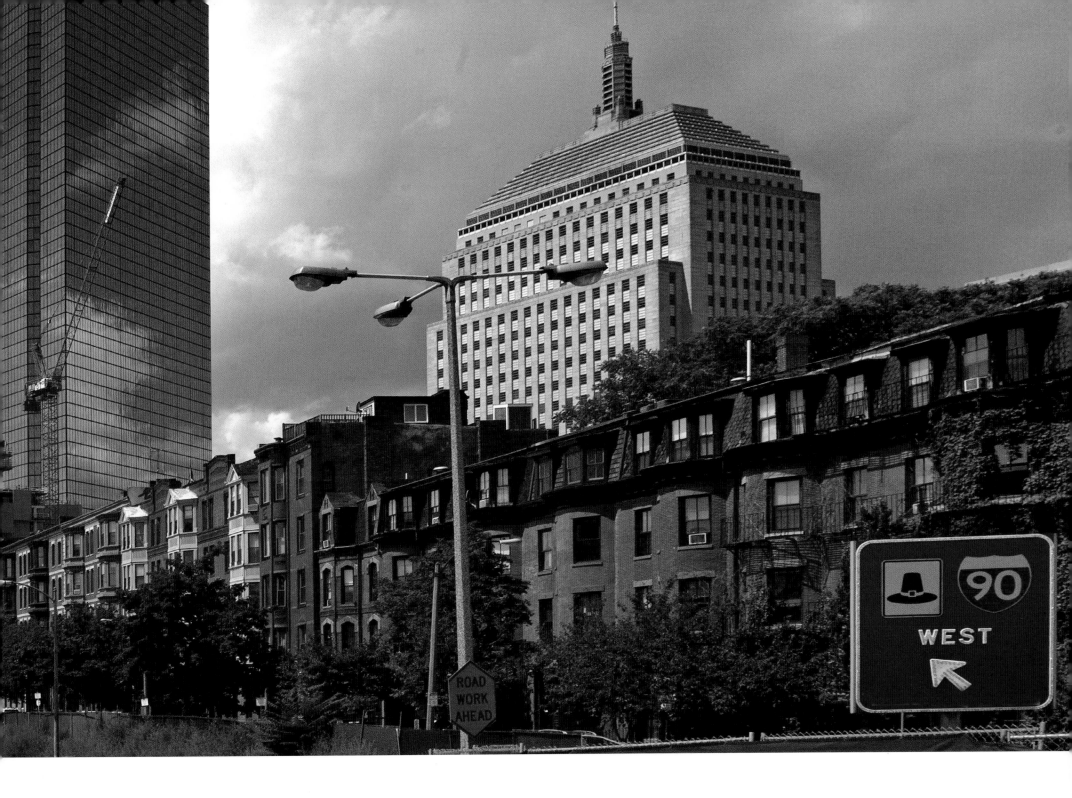

A view along Boylston Street on the left and the distinctive Church of the Covenant, located on the corner of Berkeley and Newbury Streets. With a 240-foot steeple, it is higher than the Bunker Hill Monument. In the late 1800s, Tiffany Glass and Decorating Co. installed the stained glass windows.

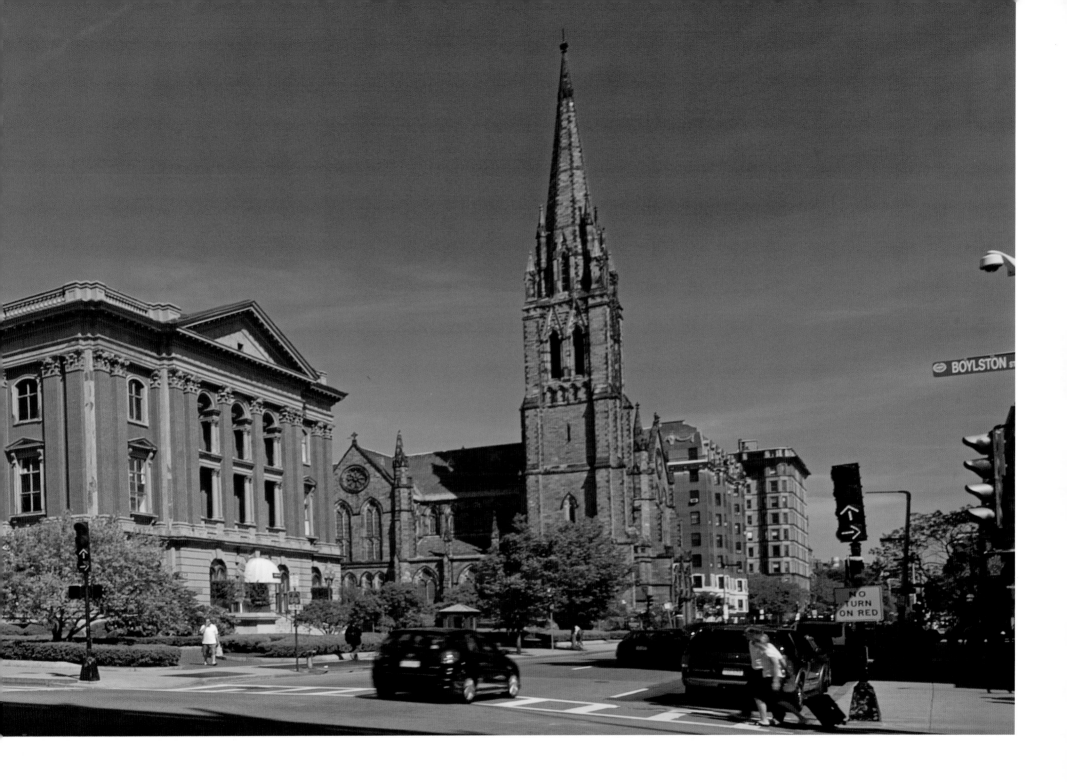

101

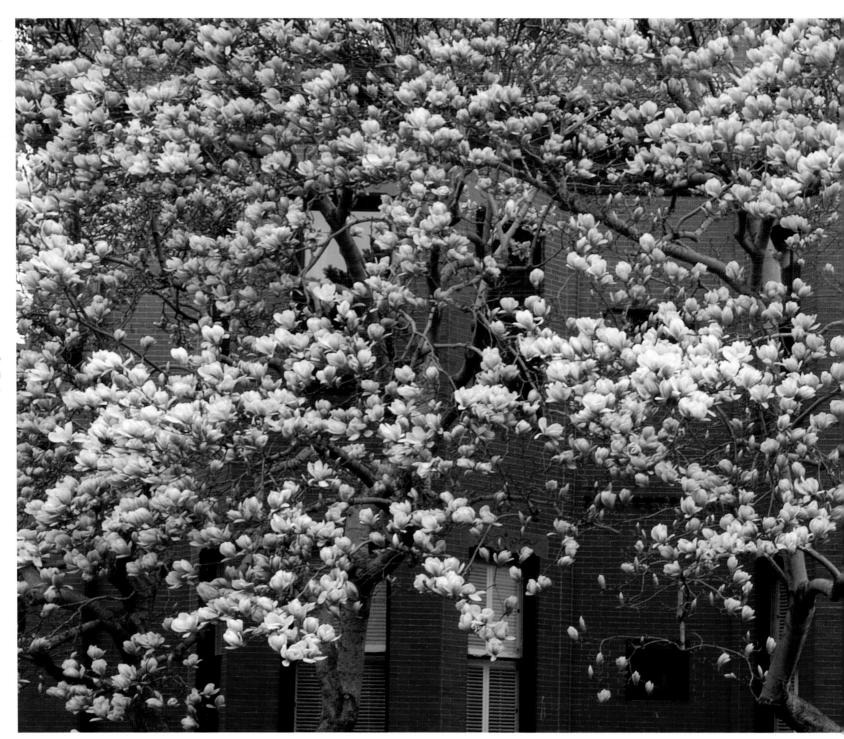

In the springtime, cherry blossoms bloom along Marlborough Street.

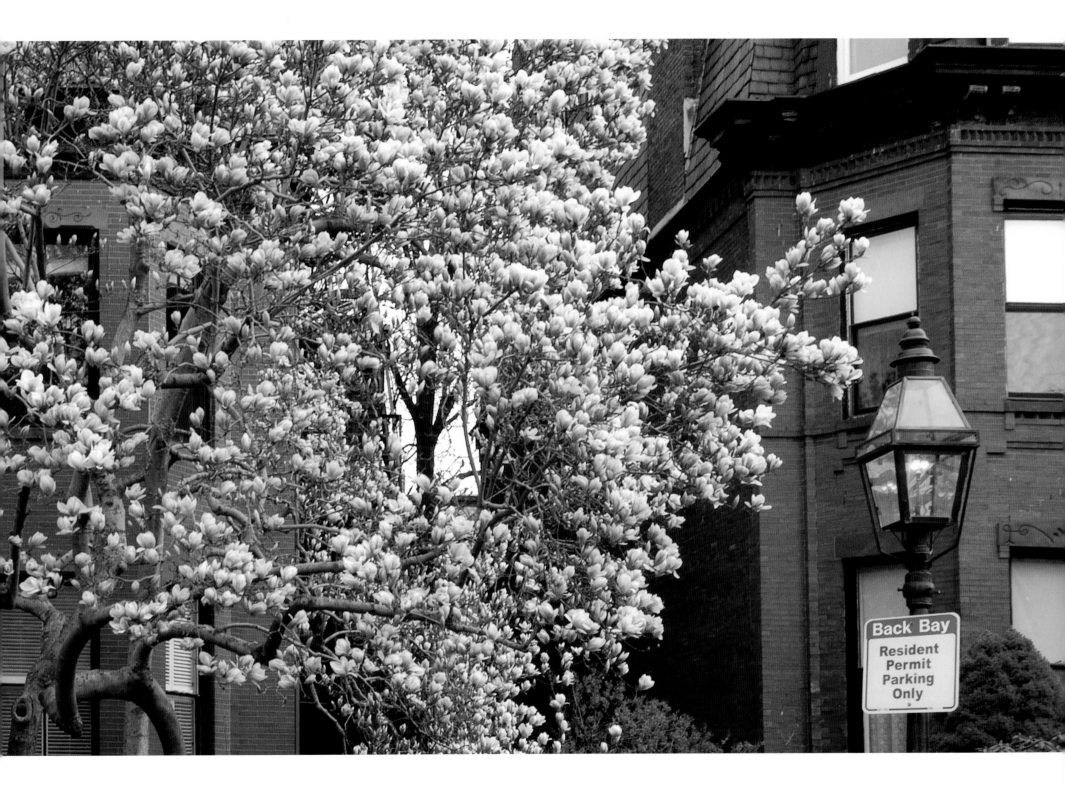

Newbury Street is eight blocks of boutiques, salons, and fine dining, and sometimes is referred to as the "Rodeo Drive of the East." With wide tree-lined sidewalks and street vendors, Newbury Street is the place to be in Boston for "high-end" shopping.

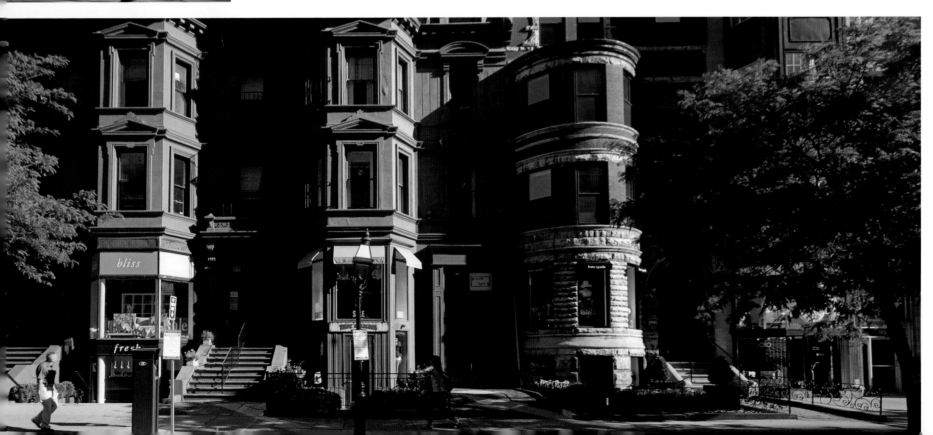

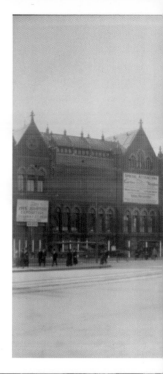

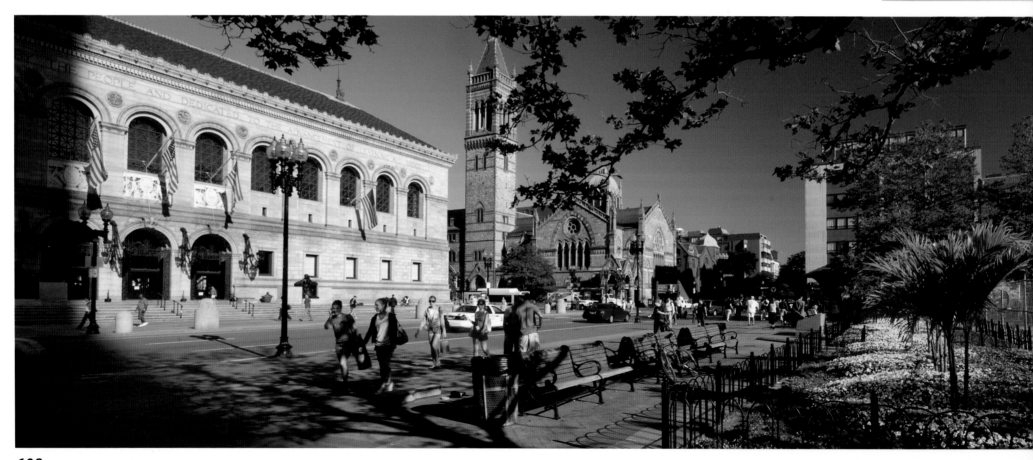

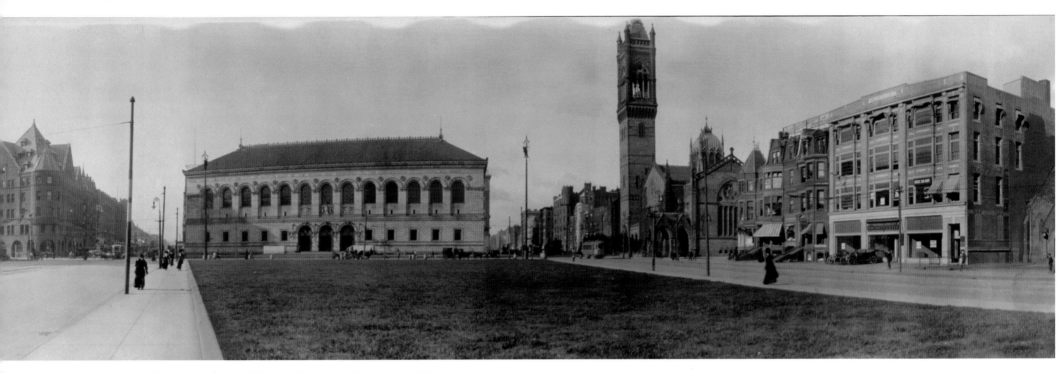

These two views of Copley Square, taken nearly 100 years apart, show the Boston Public Library and the Old South Church. In the older image is the original location of the Museum of Fine Arts, the building to the left. Named for the famous American portraitist, John Singleton Copley, the square is a busy area in the Back Bay with numerous activities available (Courtesy of Library of Congress).

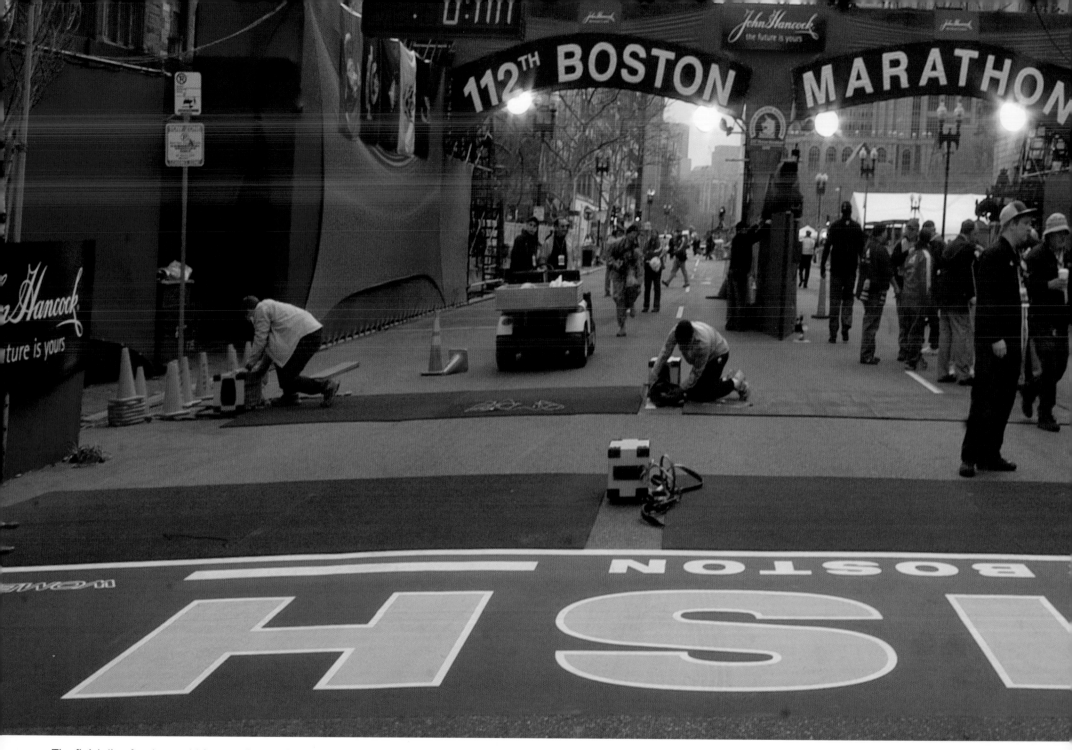

The finish line for the world famous Boston Marathon is on Boylston Street next to the Boston Public Library, just before entering Copley Square.

Another view of Copley Square, this time looking east with the distinctive and famous Trinity Church in the center. The original church burned during the Great Fire of 1872, and this building was constructed during the 1870s in the Richardsonian Romanesque style that features a clay tile roof, rough stone, heavy arches, and a massive tower.

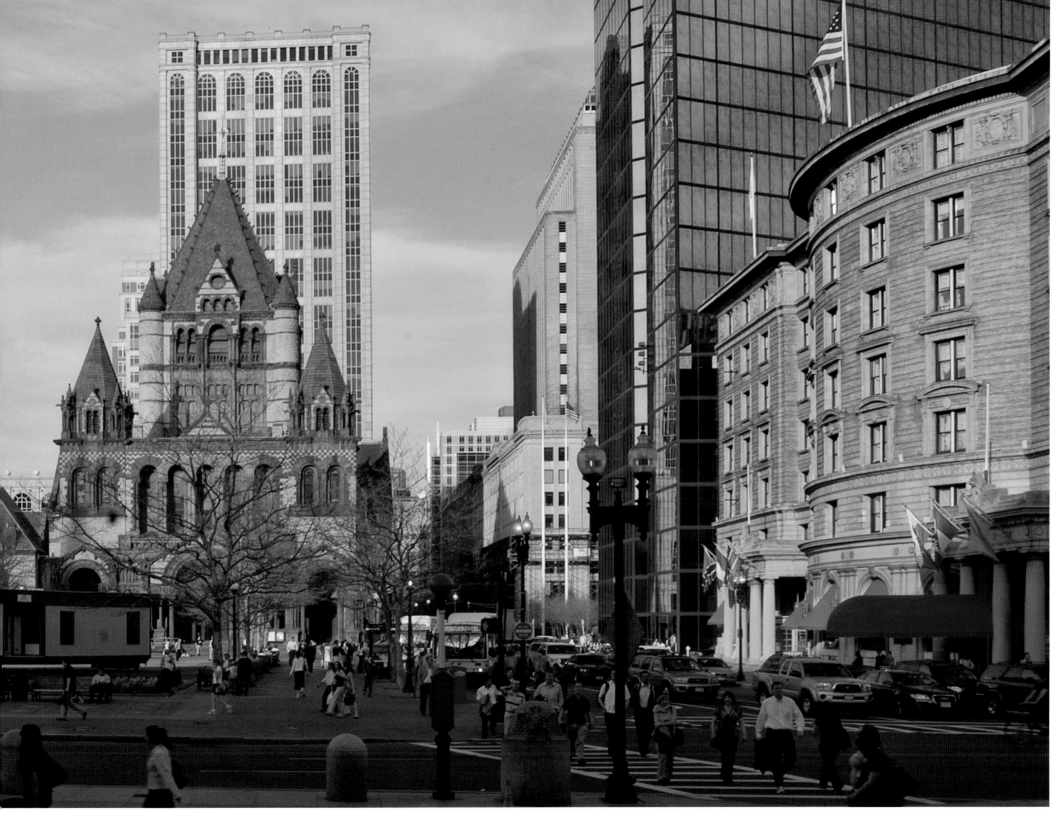

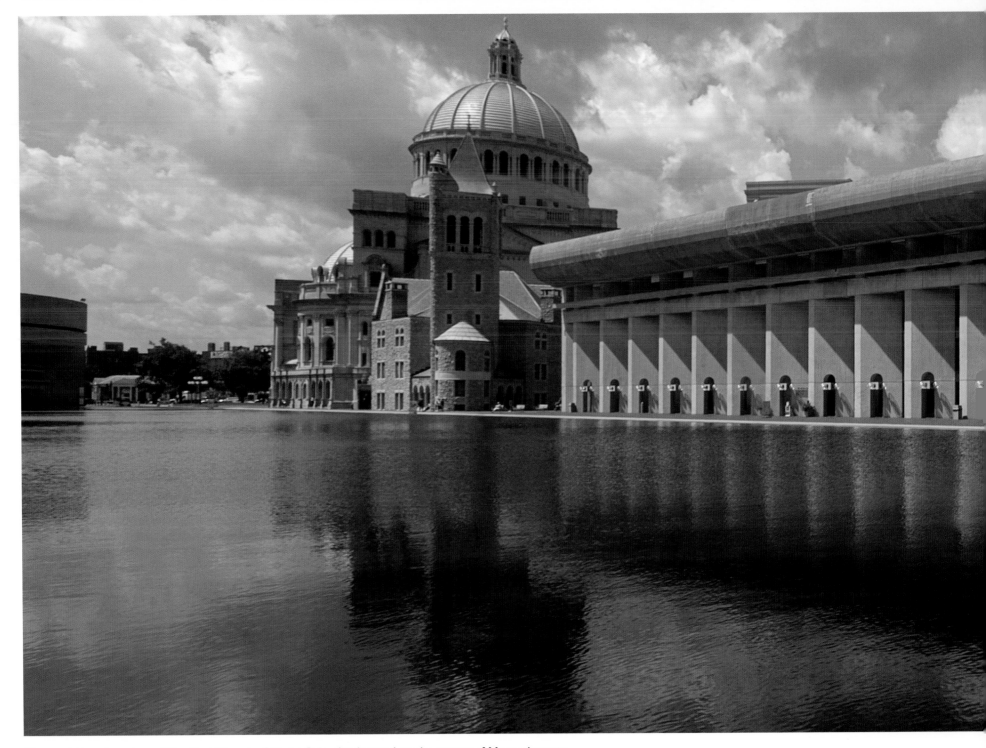

The world headquarters of the First Church of Christ Scientist, located on the corner of Massachusetts Avenue and Huntington Avenue. The Mother Church rises over the reflecting pool. The church was founded in 1879 by Mary Baker Eddy.

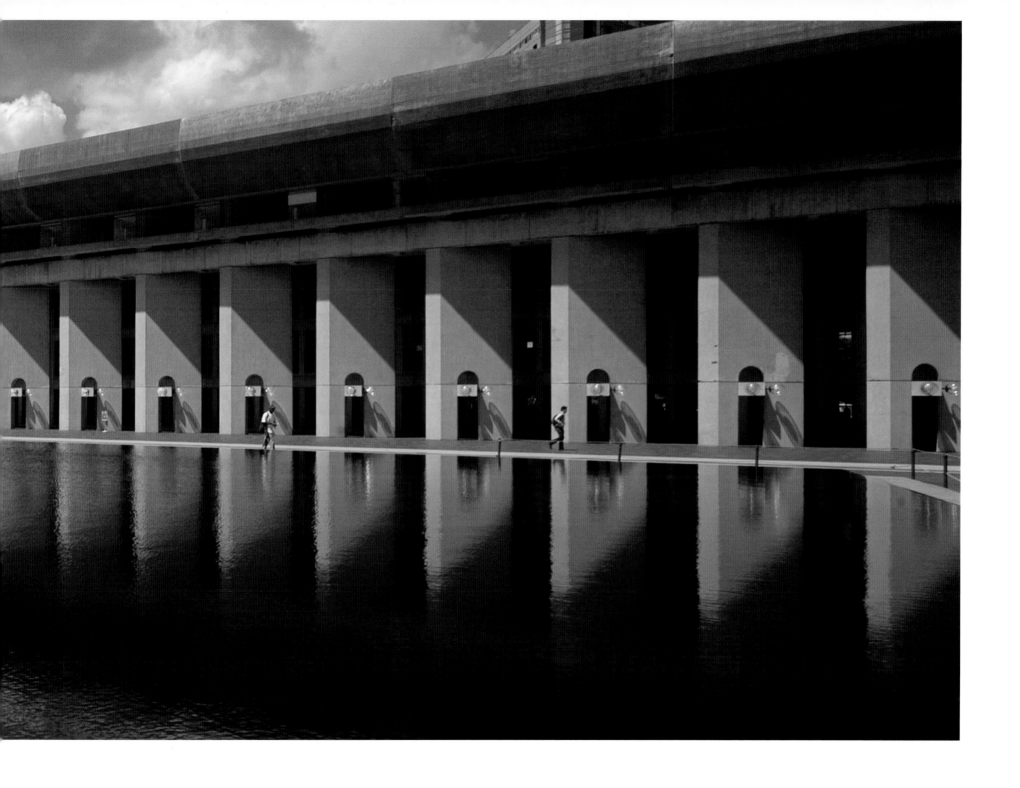

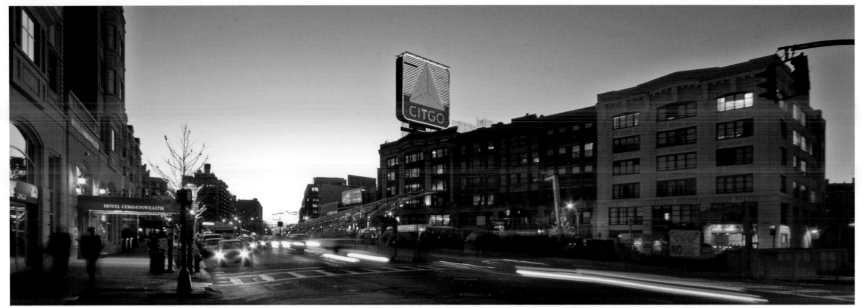

Kenmore Square at night, where Commonwealth Avenue and Beacon Street cross as they head out of town. Built in 1965 and now a preserved landmark, the flashing CITGO sign is instantly recognizable. It can be seen over the left field wall in Fenway Park, as well as all along the Charles River.

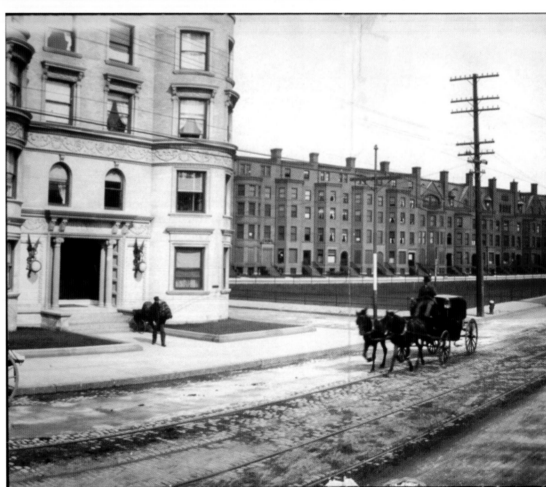

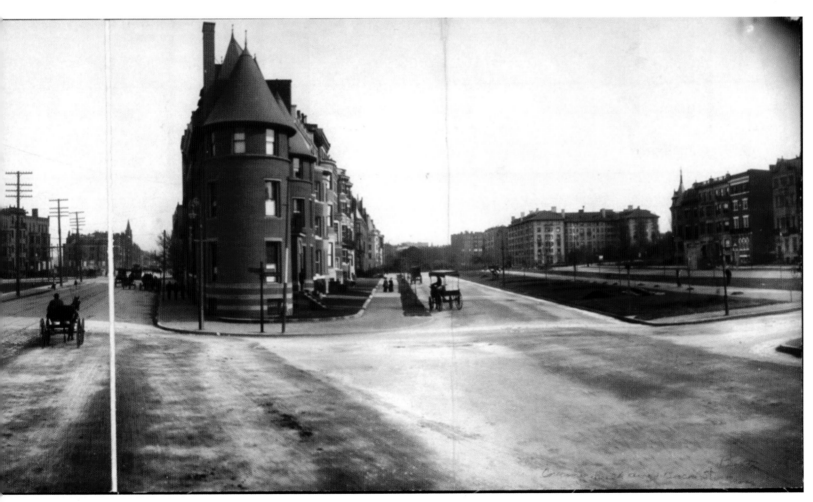

This panorama dating from the early 1900s looks east from Kenmore Square, with Beacon Street on the left and Commonwealth Avenue on the right (Courtesy of Library of Congress).

Fenway Park is the oldest baseball stadium in major league baseball, with the first game being played there in 1912 soon after the sinking of the *Titanic*. 1912 was a banner year with the Red Sox as they won the World Series.

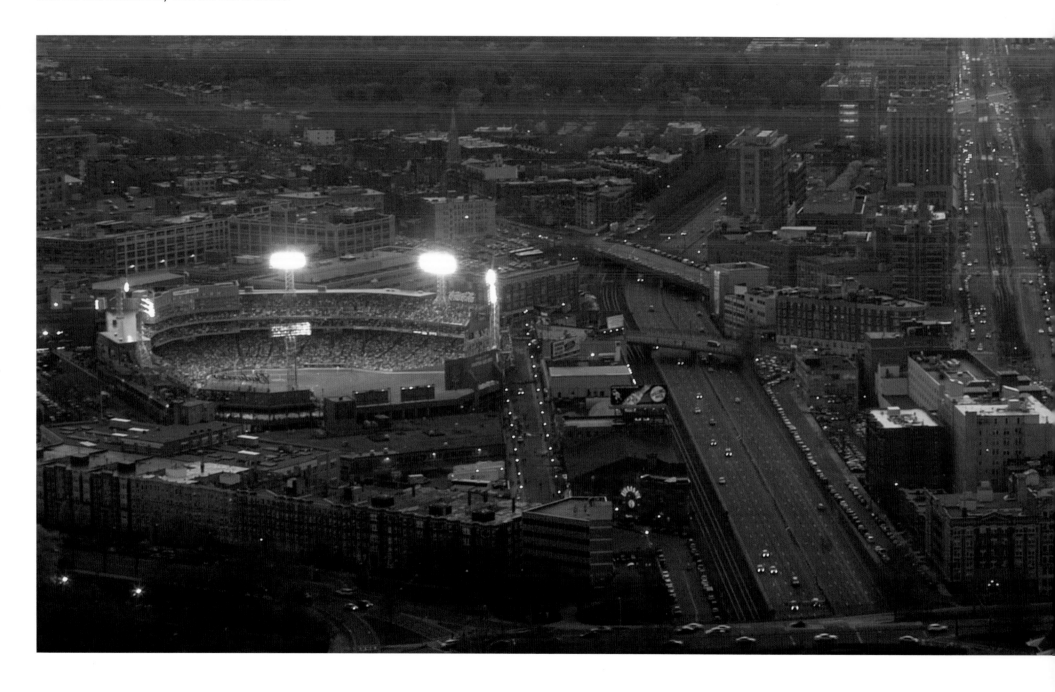

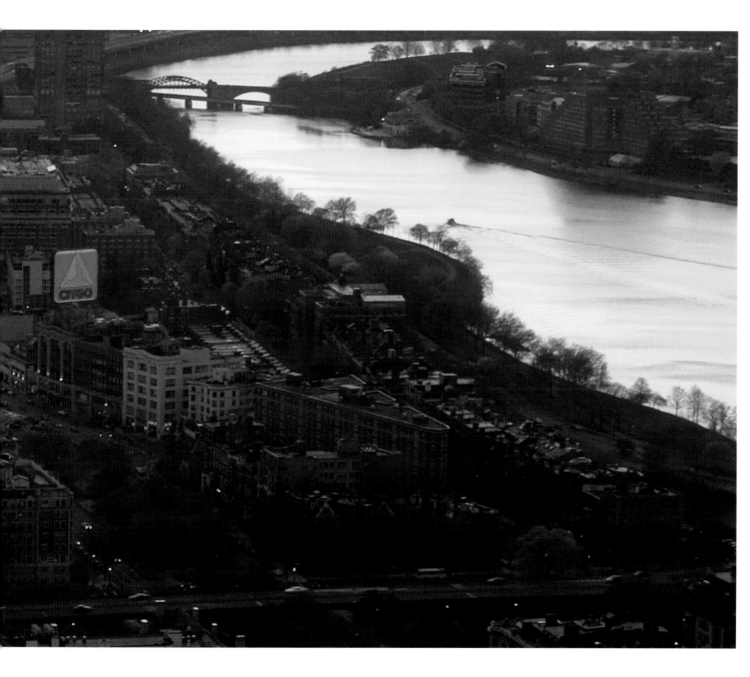

From the Prudential Center, a night baseball game at Fenway with the distinctive CITGO sign in Kenmore Square and the Charles River on the right.

Present-day Fenway Park looking from the right field stands towards the Green Monster.

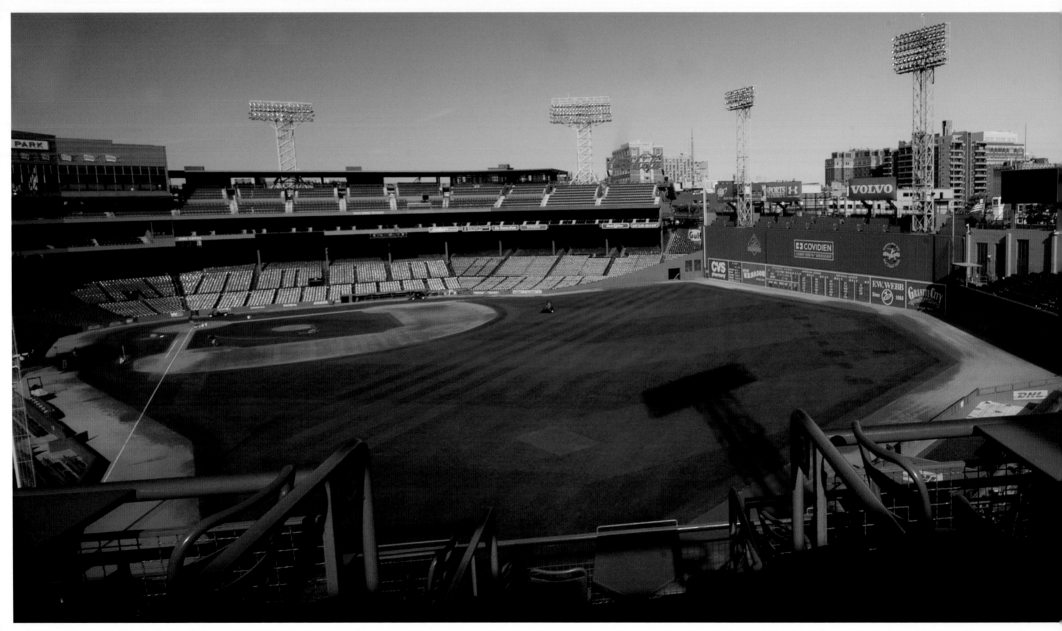

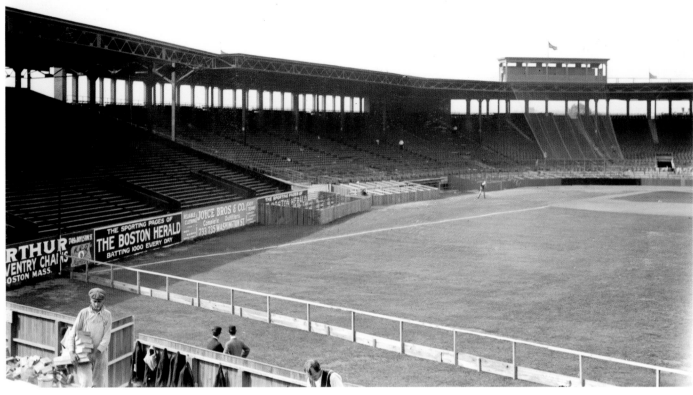

As view of Fenway taken more than 70 years ago.
(Courtesy of Library of Congress).

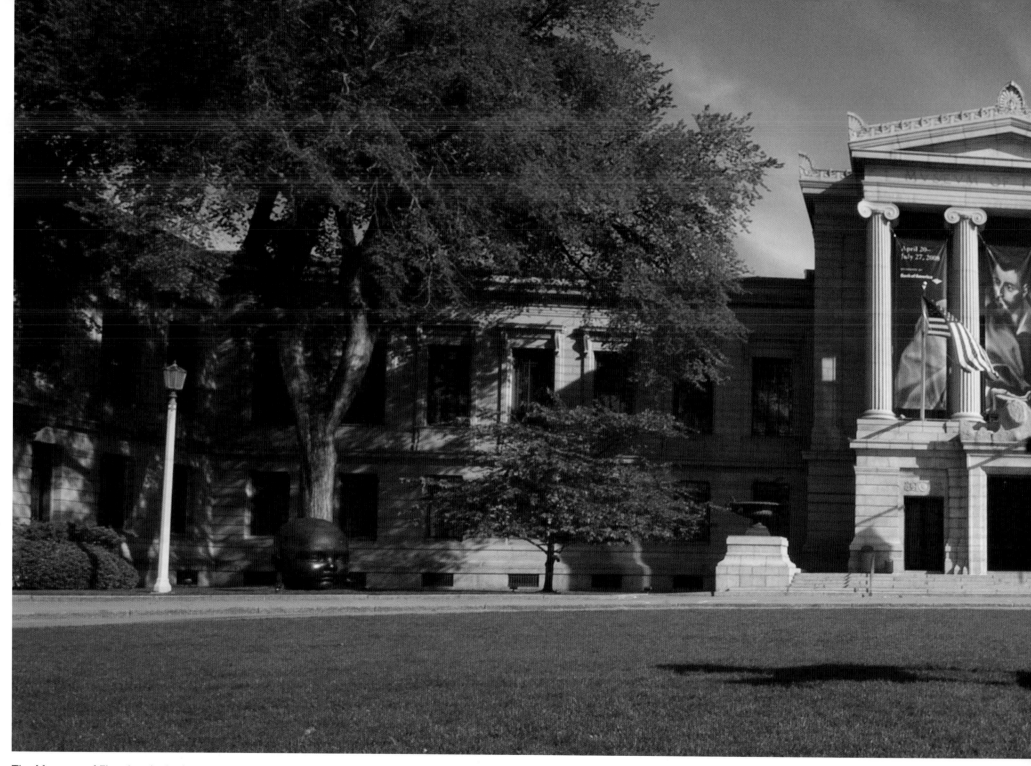

The Museum of Fine Arts is the largest museum in New England with over 450,000 works of art and artifacts. A Native American Statue, *Appeal to the Great Spirit,* stands at the entrance.

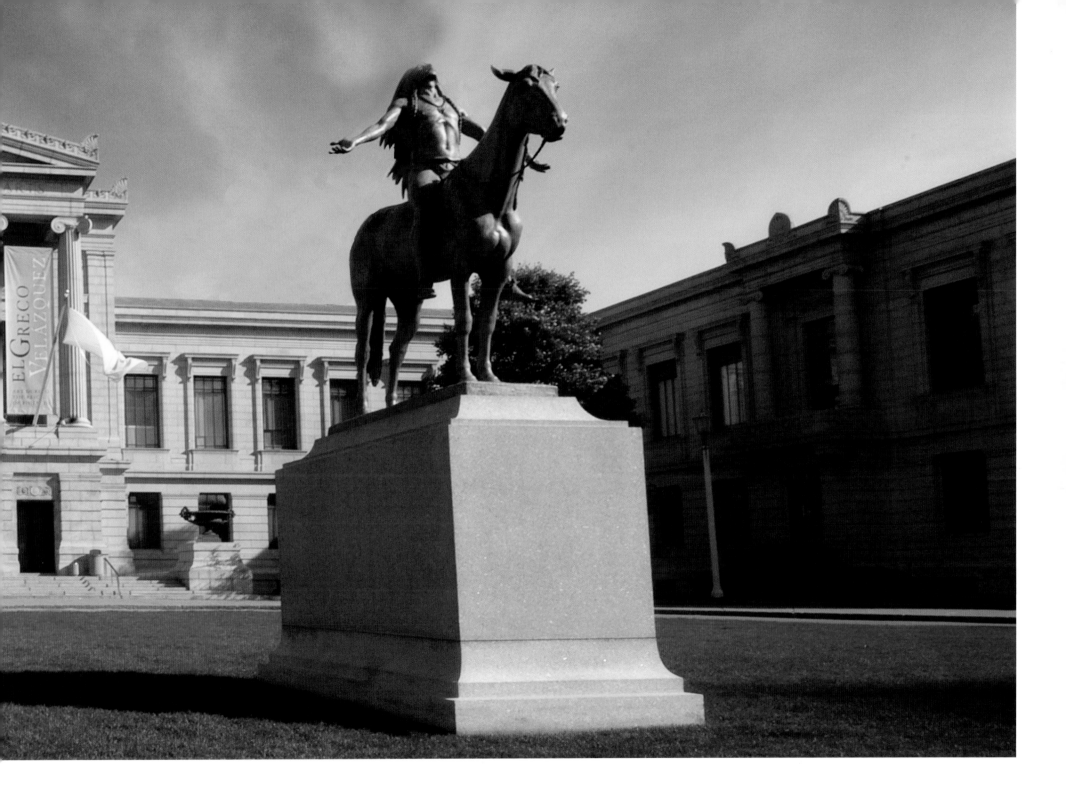

The following two views are from the Cambridge side of the Charles River.

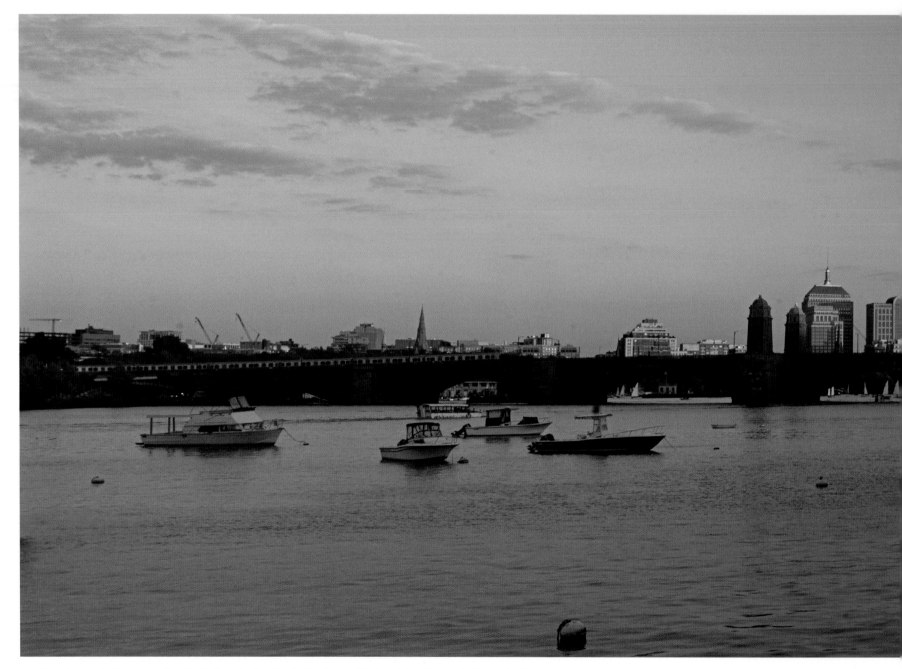

Looking towards the west, the Back Bay skyline is distinctive, with the John Hancock Tower in the center and the Prudential Center in the distance.

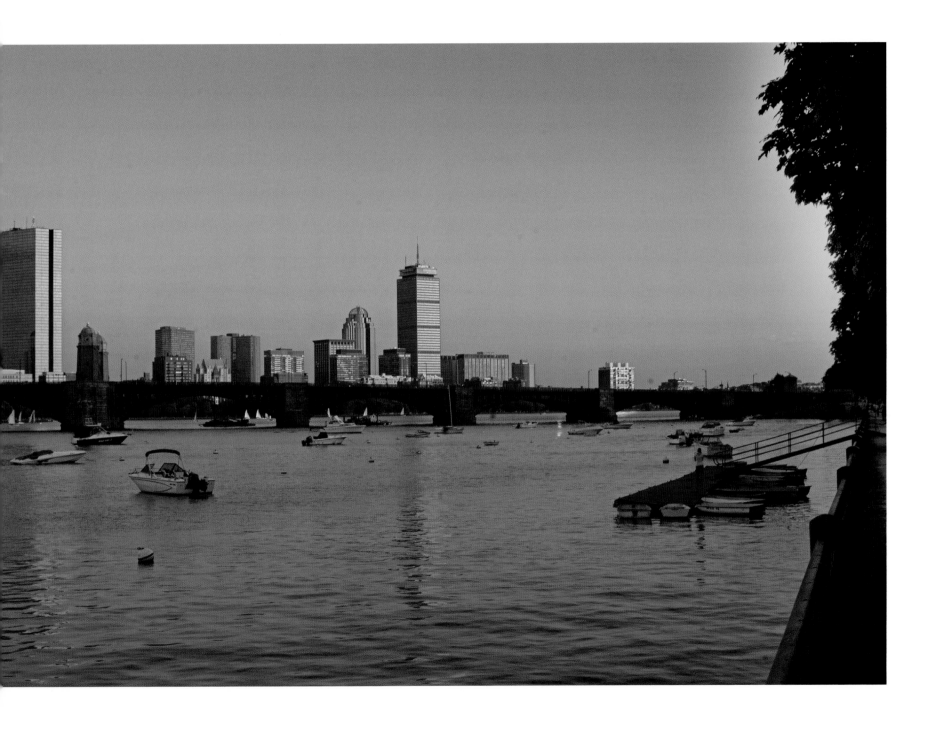

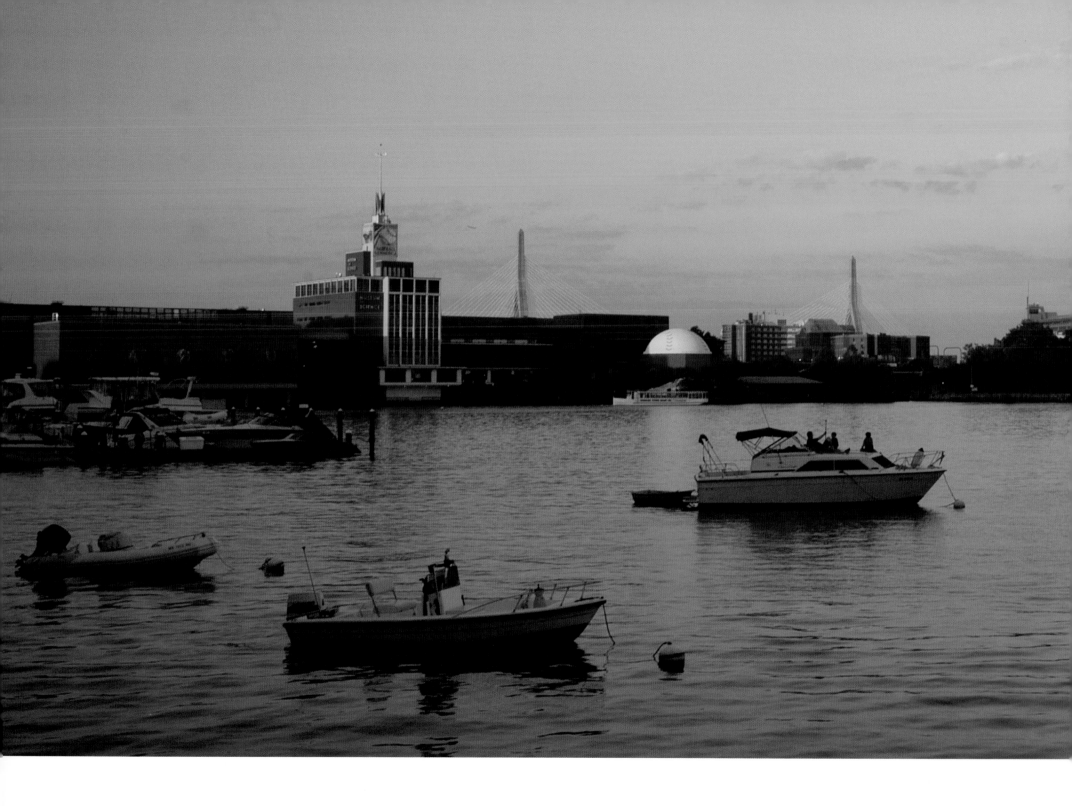

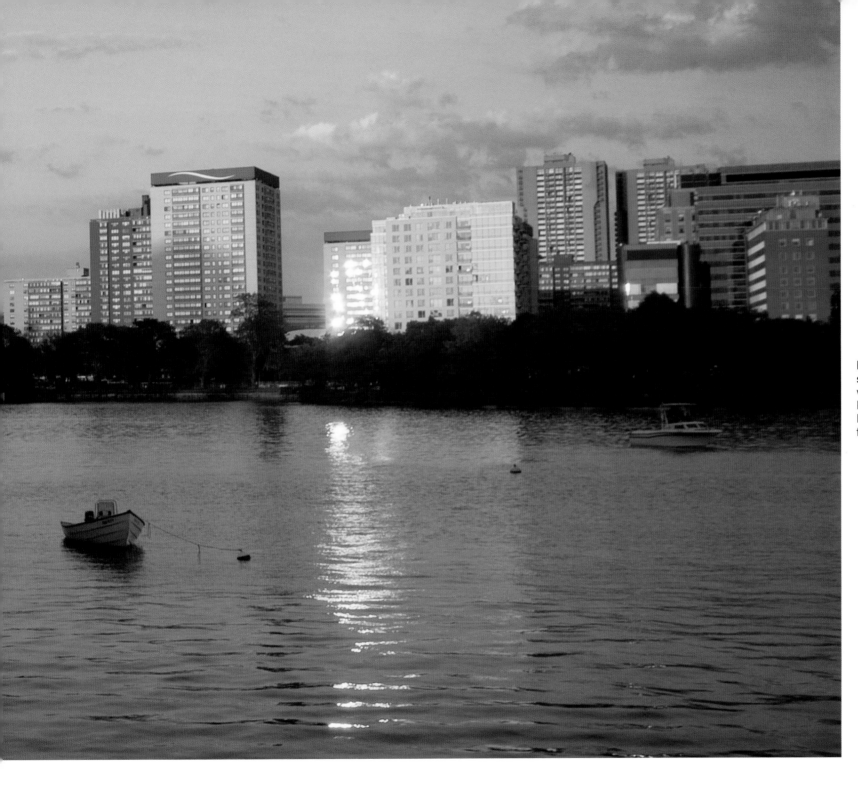

Looking to the east, the Museum of Science is on the left with the nearby Charles River Dams and the West End with Boston's renowned medical facilities , on the right.

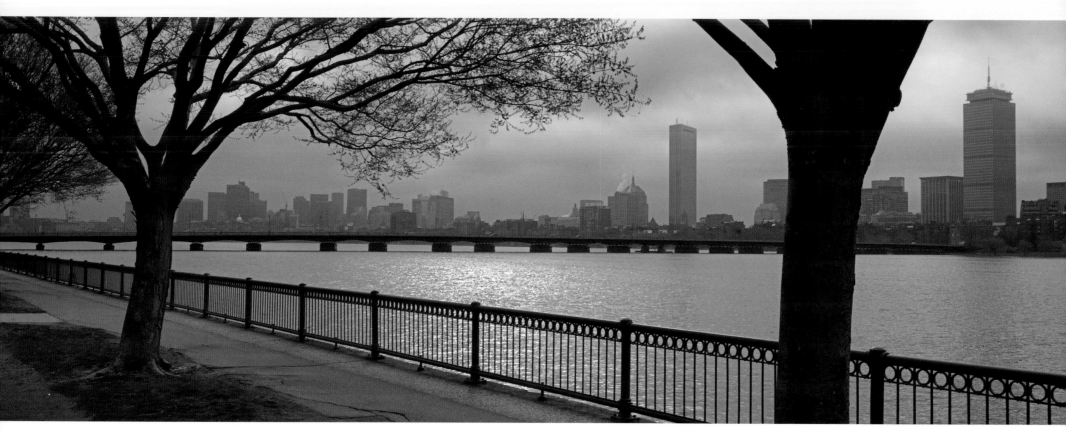

Storm clouds cover the Back Bay in this scene looking across the Charles River.

Trees bloom in the spring in the world famous Arnold Arboretum. With 265 acres and more than 15,000 plants, the walkways and ponds allow visitors to wander and study woody plants from around the world.

Dorchester Heights is the highest point in South Boston, commanding outstanding views of the city and harbor. Famous since the Revolutionary War, the Heights was fortified by George Washington during the conflict in 1776.

Maintained by the National Park Service, The Dorchester Heights Monument, completed in 1902, is 115 ft tall and built of Georgia white marble designed as a Federal style church steeple.

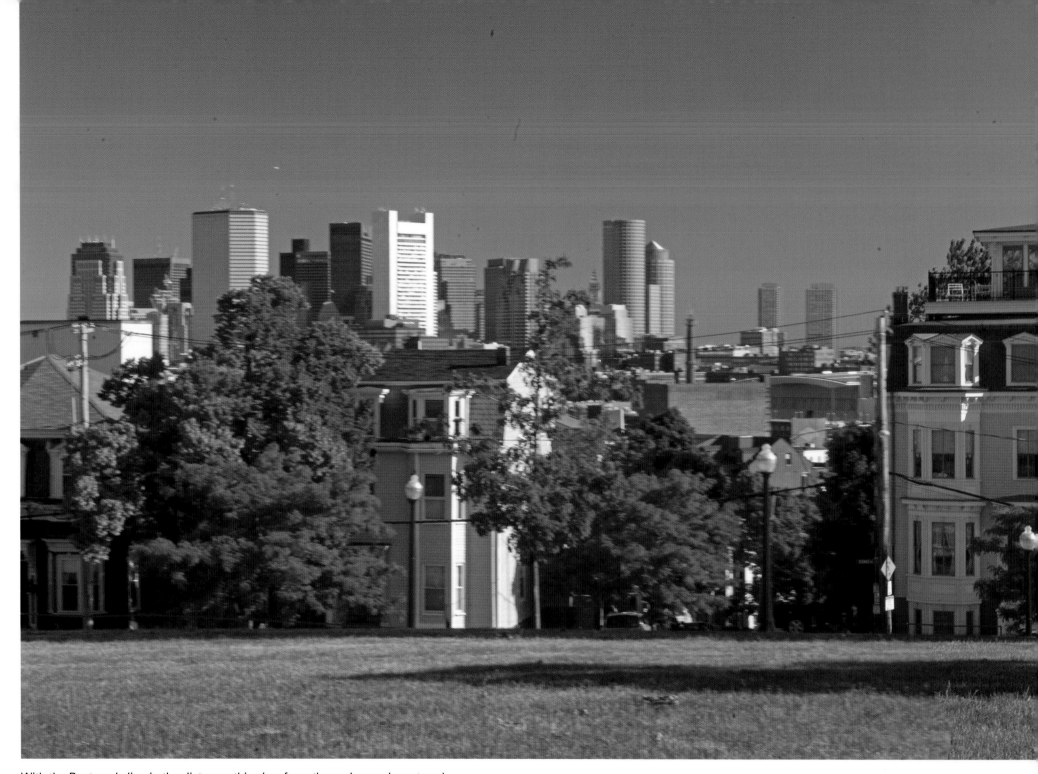

With the Boston skyline in the distance, this view from the park reveals restored fashionable Victorian homes on the nearby streets.

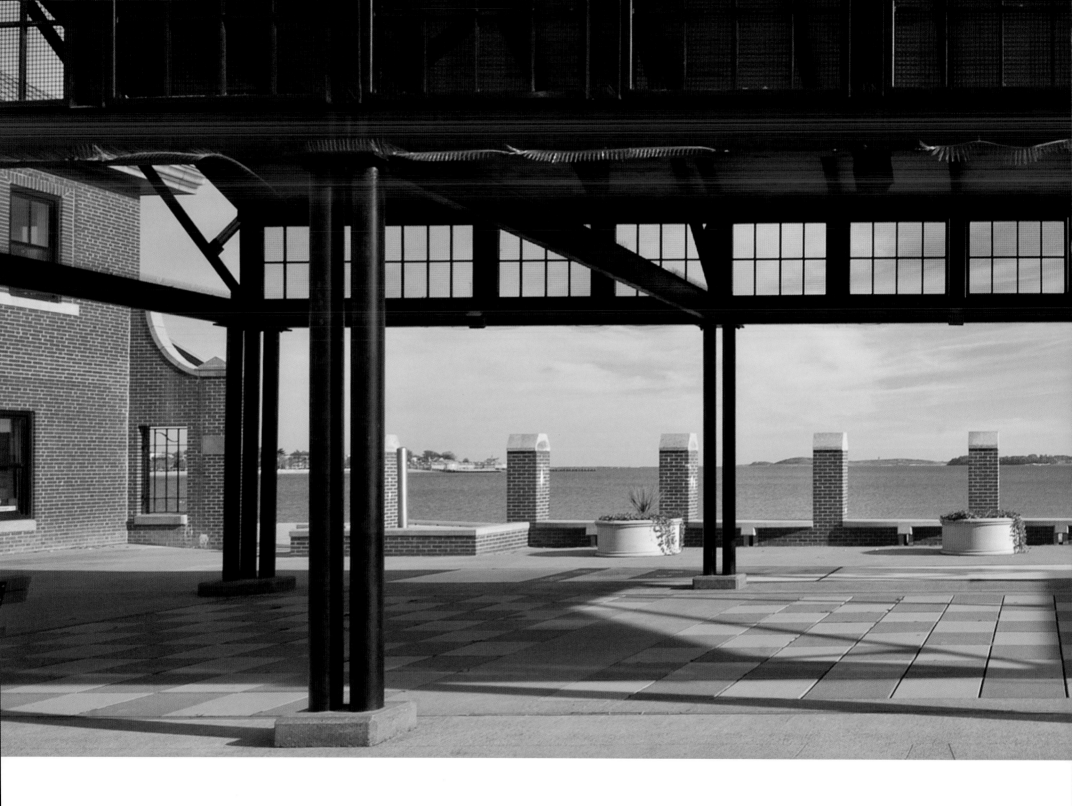

A pavilion along Carson Beach in South Boston overlooking Dorchester Bay.

Tenean Beach in Dorchester, looking north towards South Boston. The distinctive graphics on the gas tank in the background were designed by Sister Corita Kent.

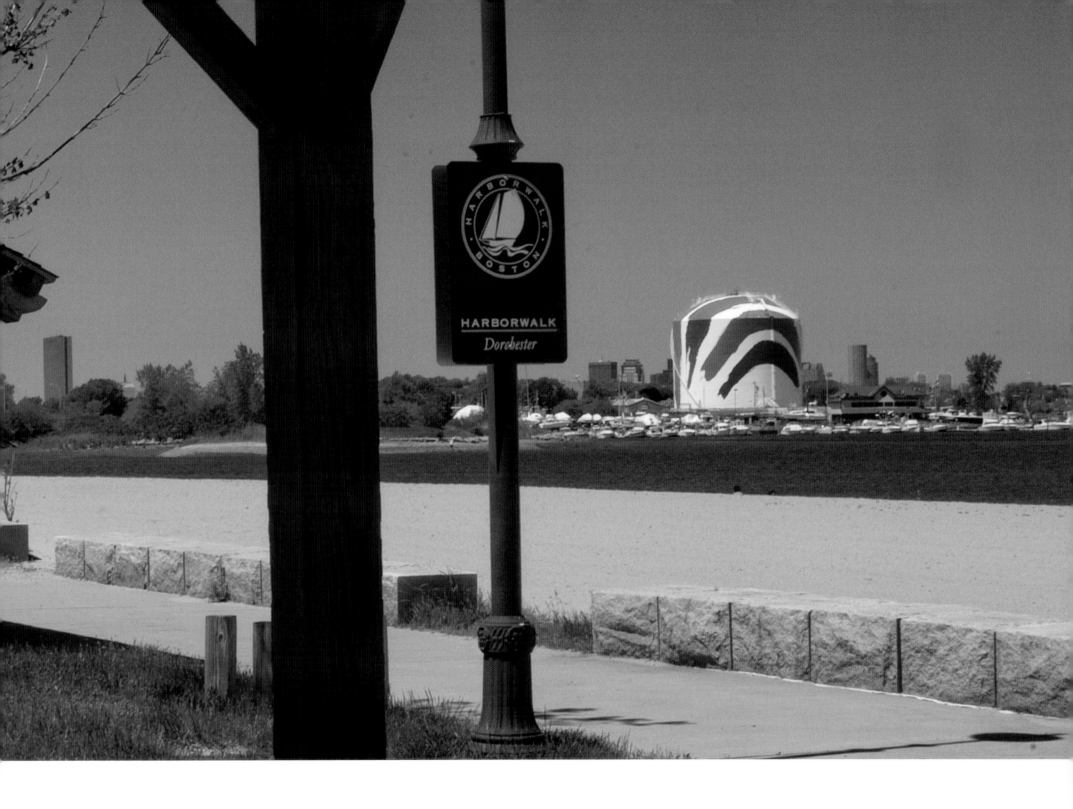

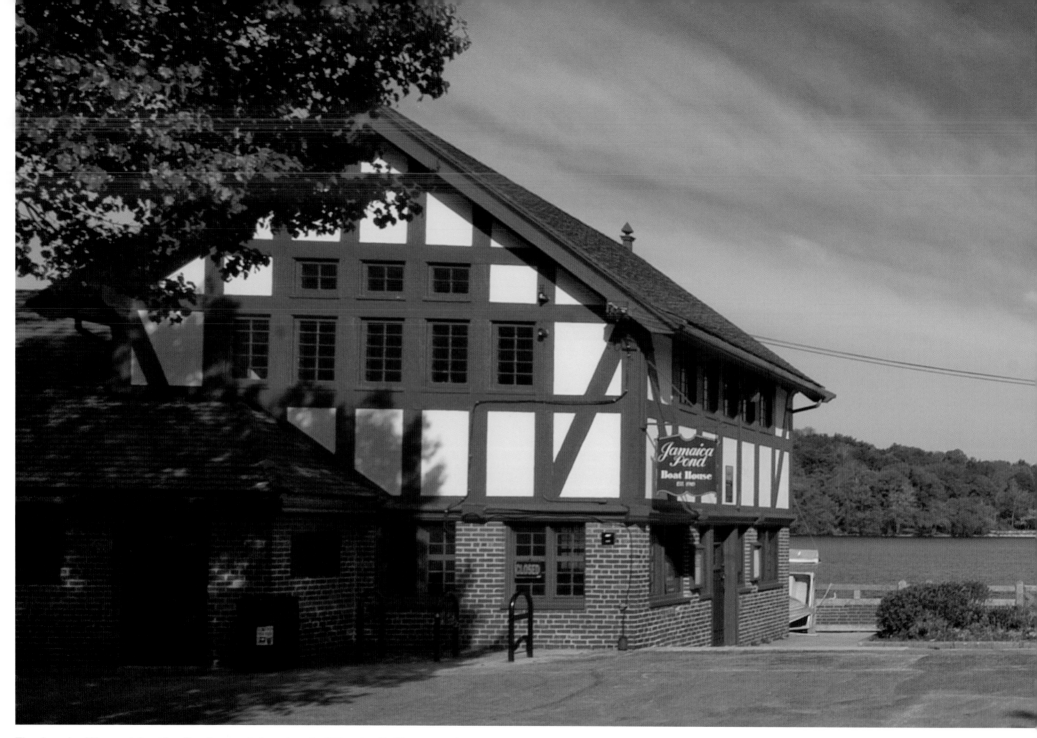

The Jamaica Way and Jamaica Pond are an integral part of Olmstead's Greenway that starts in downtown Boston and extends to the Arnold Arboretum. The boat house rents a variety of craft to use on the pond.

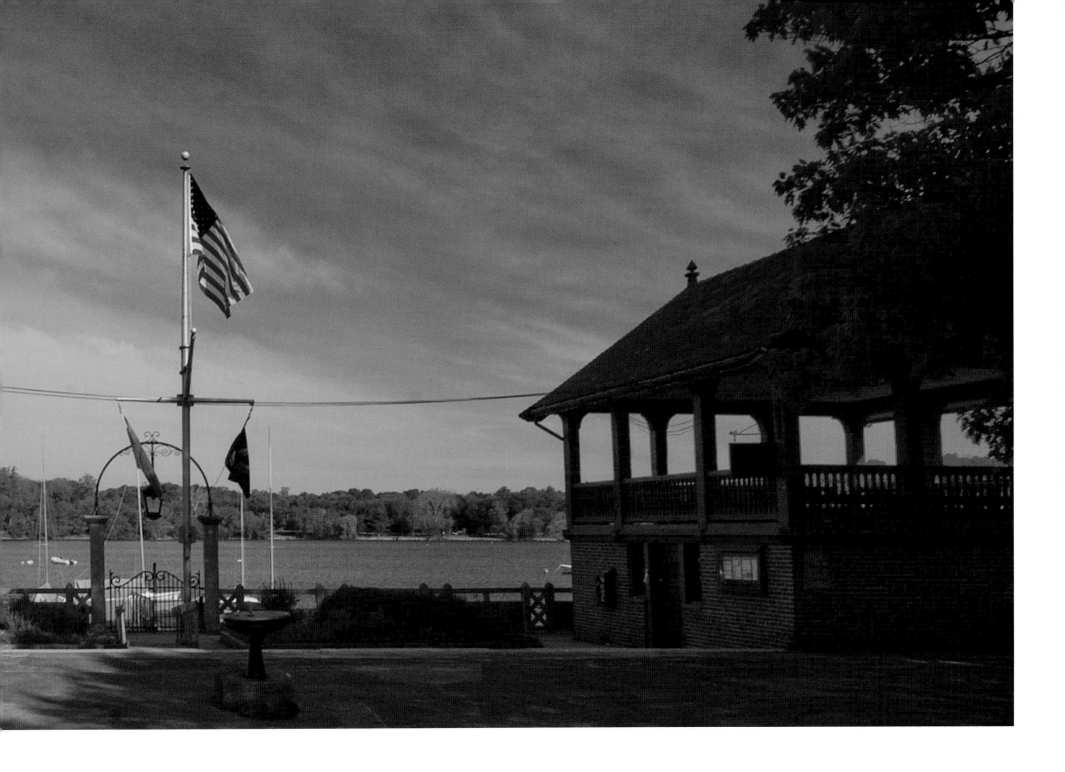

The public can walk around the pond, which is encircled by a walkway. No swimming is allowed, but fisherman find it very appealing , as the pond is stocked by the Commonwealth of Massachusetts.

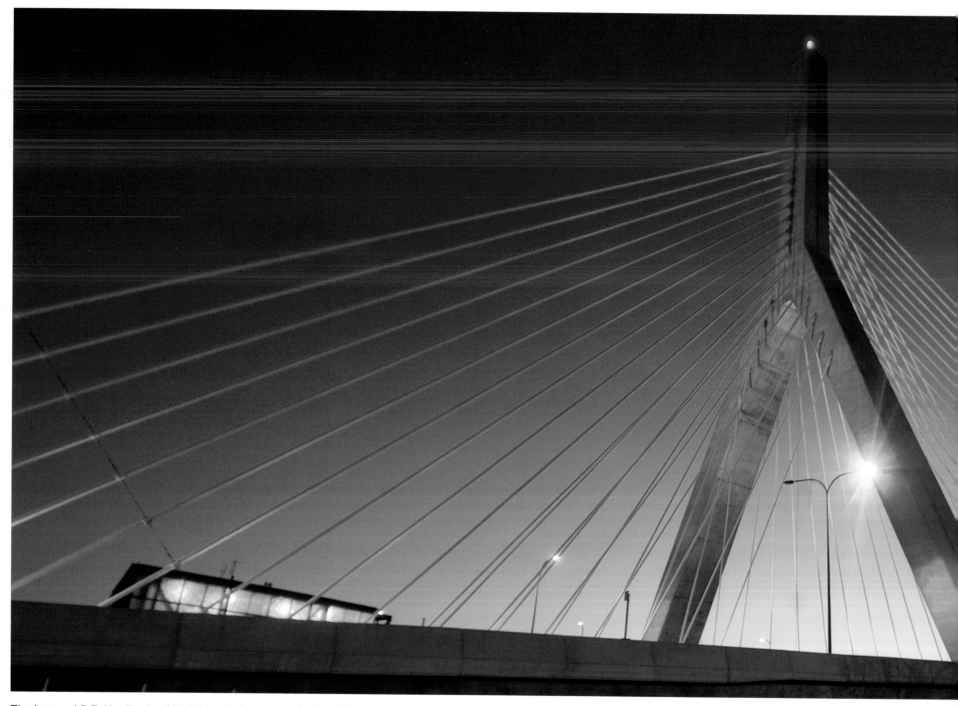

The Leonard P. Zakim Bunker Hill Bridge is the newest bridge in Boston and links the tunnels under the North End and Interstate 93 North. Interestingly, sun holes were constructed in the bridge to allow light to reach the water below, enabling fish to migrate past the structure. Bunker Hill Monument, as seen on the next page, is replicated at the top of each of the two bridge towers.

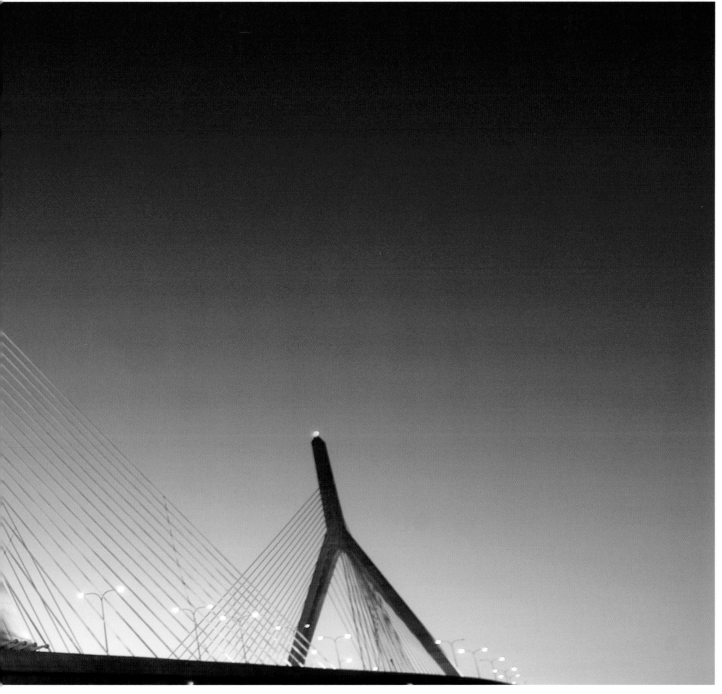

The Bunker Hill Monument in Charlestown marks the first battle of the Revolution, on June 17, 1775. The 221 foot granite obelisk was completed in 1843 with 294 steps to the top. It offers spectacular 360 degree views of Boston.

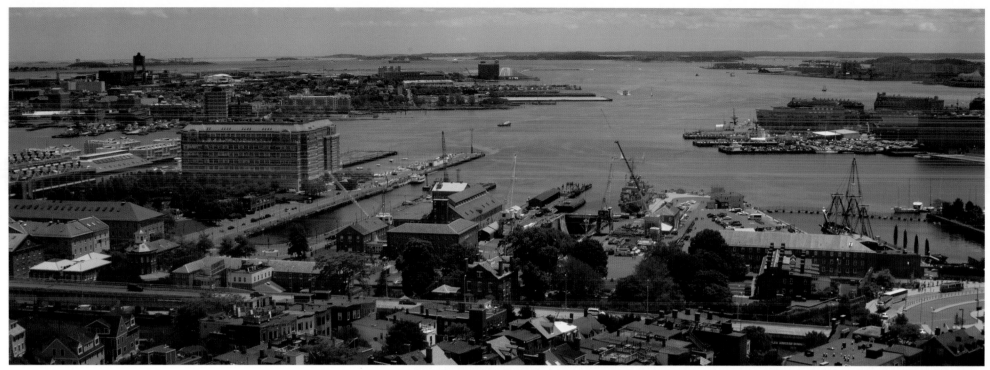

Looking south from the top of the monument, this scene has the Charlestown Navy Yard with the U.S.S. Constitution in the foreground, and Boston Harbor in the distance.

MASSACHUSETTS GATE

COLONEL WILLIAM PRESCOTT OF MASSACHUSETTS LED THE COLONIAL FORCES HERE ON BREED'S HILL. HIS COMMANDING FIGURE AND STRONG WILL INSPIRED THE FARMER SOLDIERS TO THE GREATNESS OF THE DAY. DR. JOSEPH WARREN, COMMISSIONED A MAJOR GENERAL, ELECTED TO SERVE PRESCOTT AS A PRIVATE IN THE BATTLE. DR. WARREN, AN EARLY LEADER IN THE REVOLUTION, WAS KILLED ON THIS BATTLEFIELD IN THE WANING MOMENTS OF THE CONFLICT.

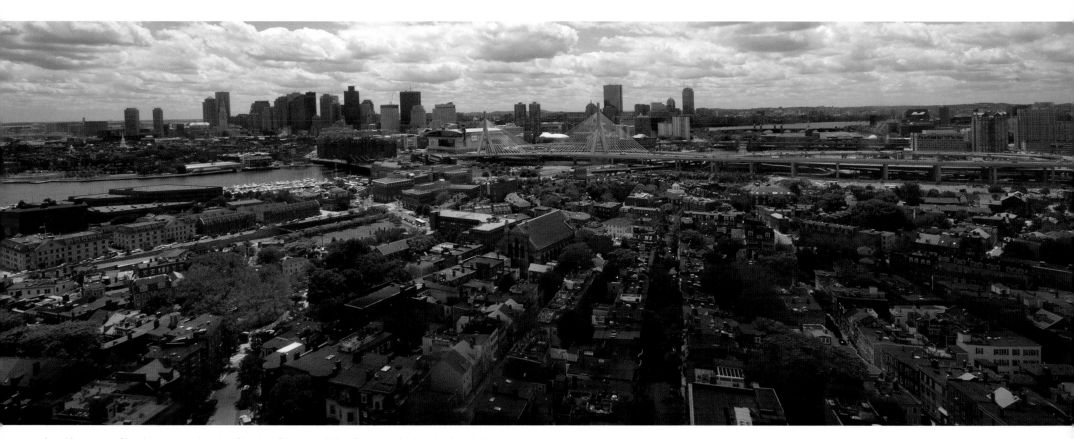

Looking over Charlestown with the Charles River and the Boston skyline in the distance.

Down the street from Bunker Hill, on the left in this image, a Soldiers and Sailor's Monument stands out in the Old Training Field Park. Brick townhouses, similar to those found on Beacon Hill, surround the park.

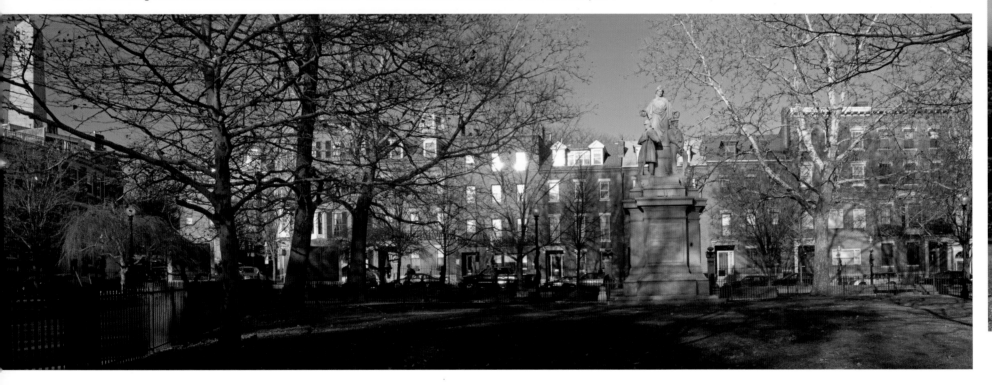

The 1805 Commandant's House in the Charlestown Navy Yard. Opened periodically, the house has an elegant interior with a spectacular view of Boston Harbor and is available for private functions.

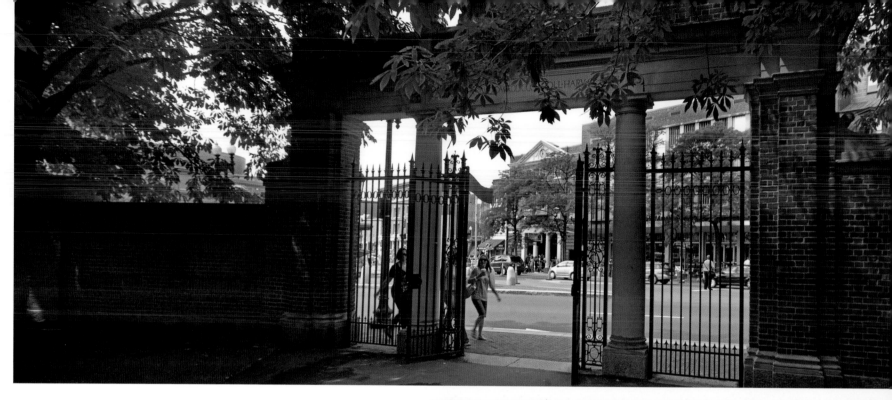

One of the more popular sites in Harvard Yard is the statue of John Harvard. It is inscribed "John Harvard, Founder, 1638," but none of these statements is true. There are no pictures available of John Harvard; he was not the founder of Harvard; and the college was founded in 1636.

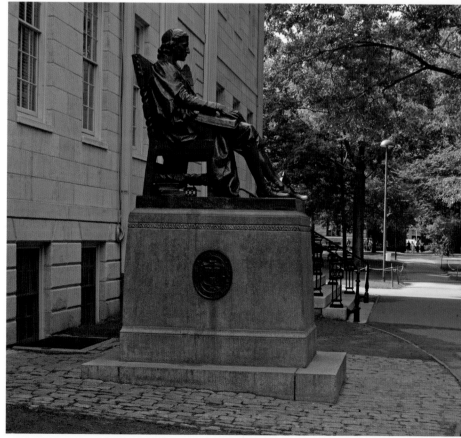

Harvard University, the oldest institution of higher education in America, is also synonymous with academic excellence. This view is looking through the Harvard Gate that leads to Harvard Square.

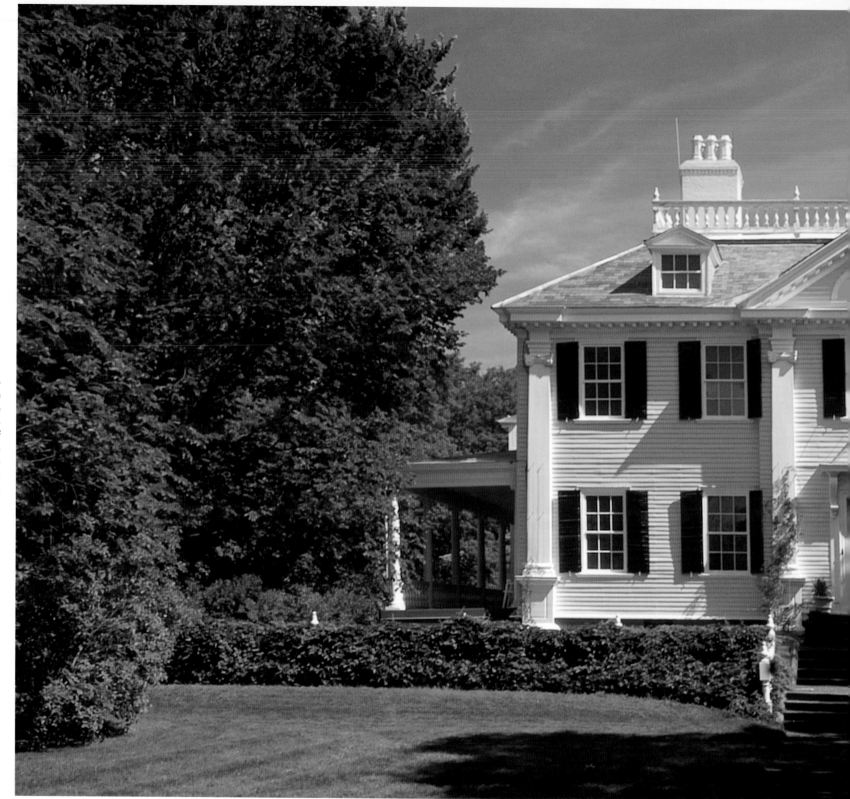

The Longfellow Historic Site on Brattle Street served as George Washington's headquarters during the Siege of Boston. Henry Wadsworth Longfellow, the famous poet, was given the house in 1843 as a wedding present.

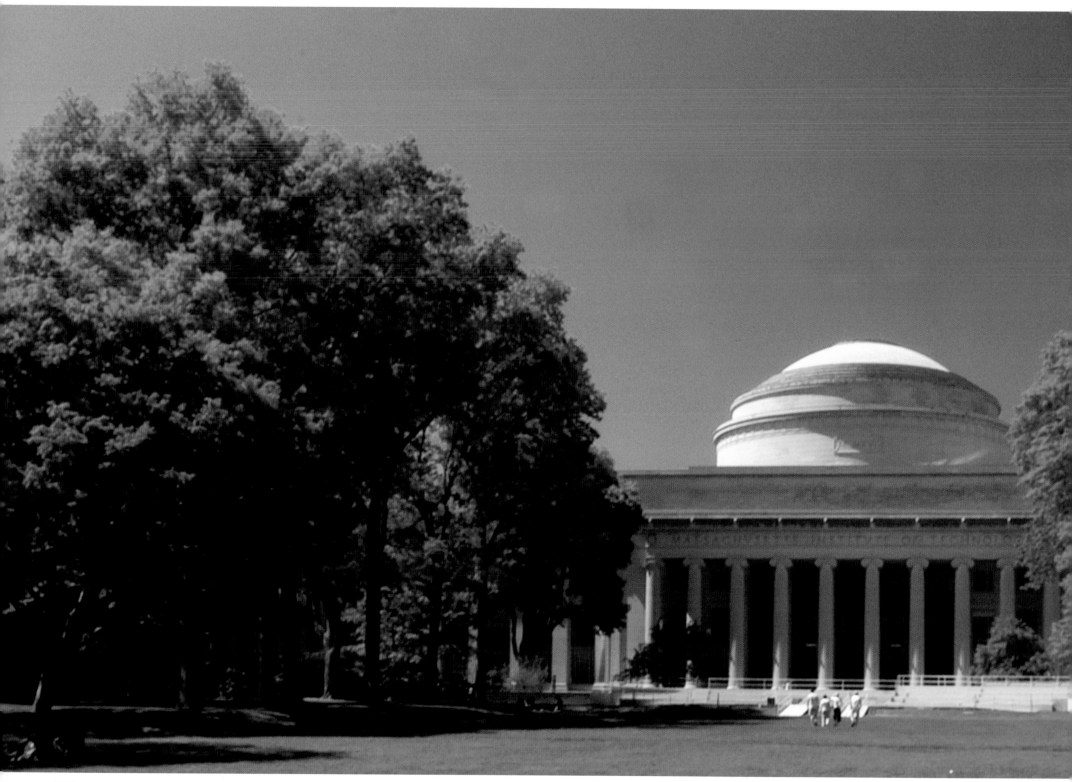

Killian Court and the Great Dome are examples of the distinguished architecture at the Massachusetts Institute of Technology. The original campus was near Copley Square, but in 1916 moved to Cambridge, just a short distance from Harvard University.

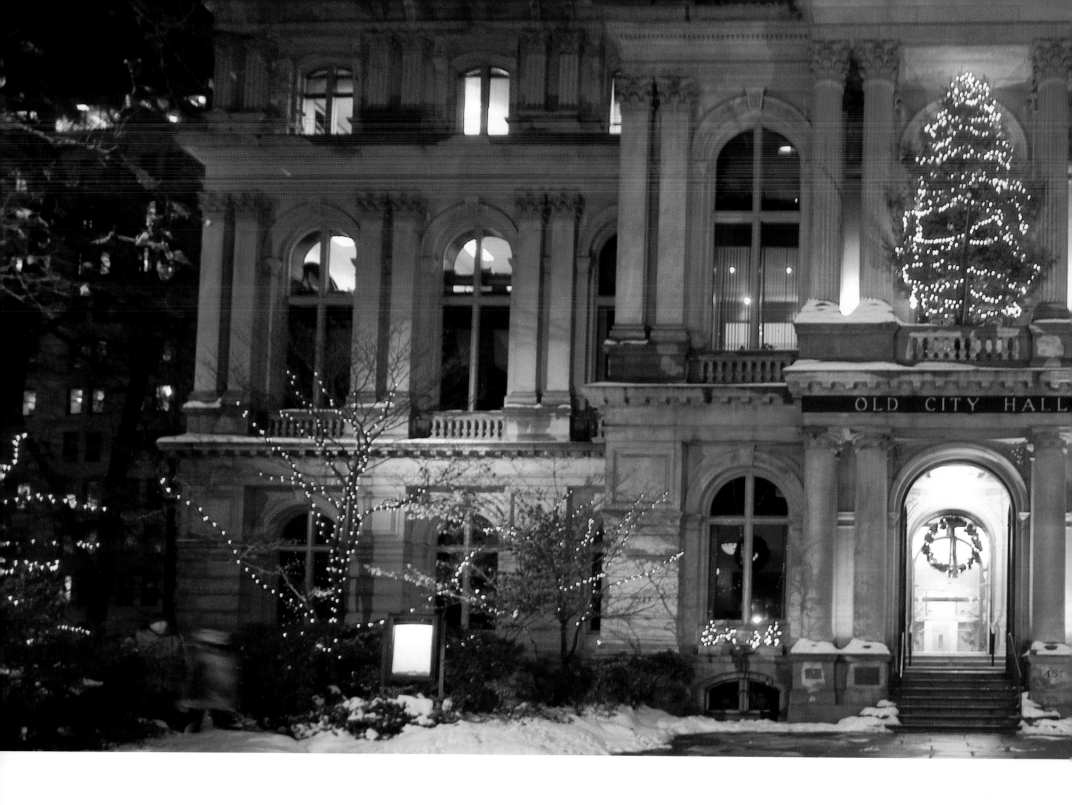

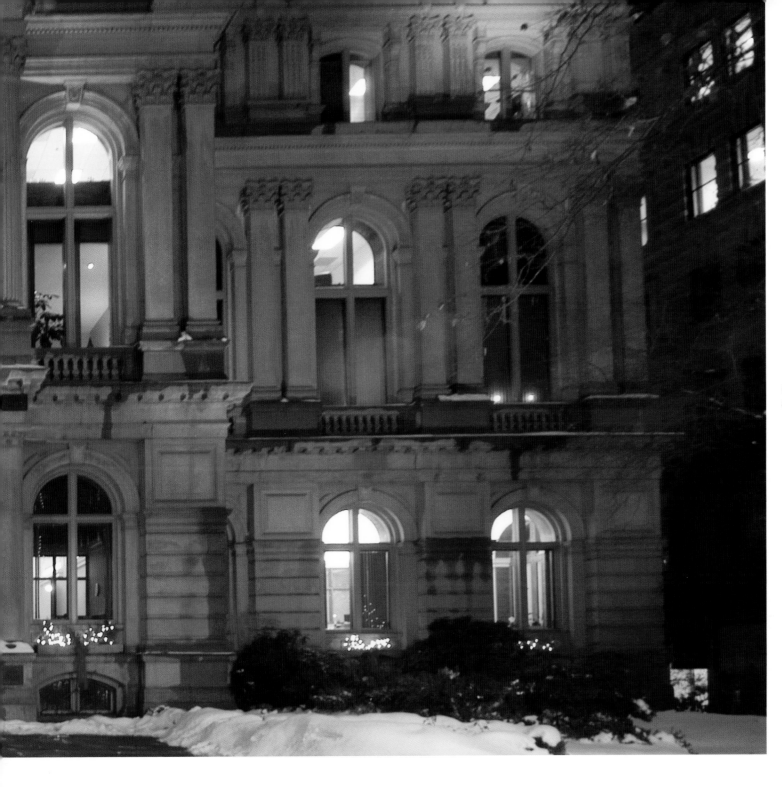

Old City Hall decorated
and lit for the holidays

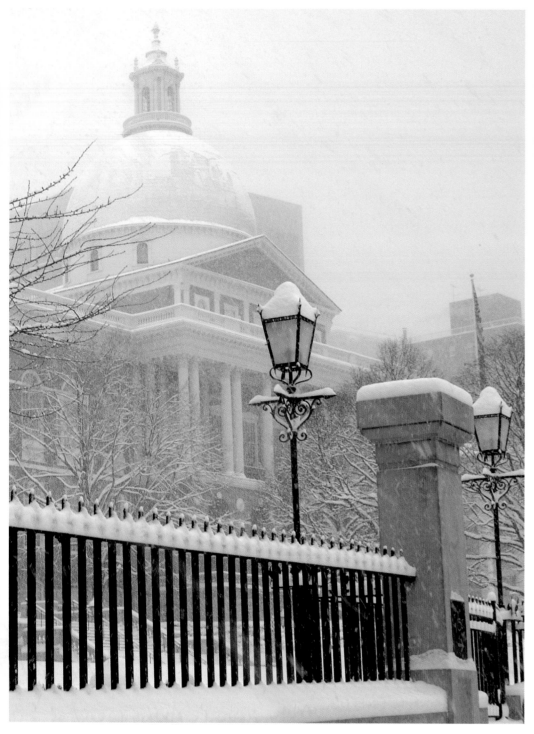

The gold dome of the State House

Holiday decorations on the Boston Common

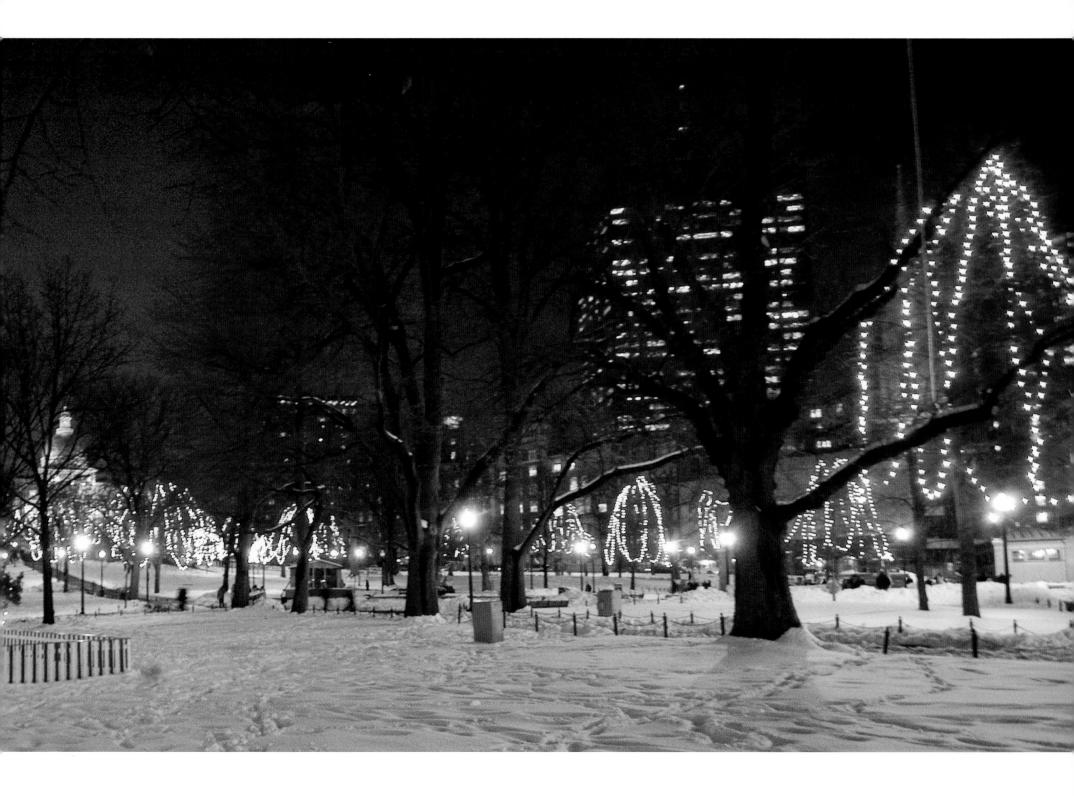

A snow covered Samuel Adams in front of Faneuil Hall.

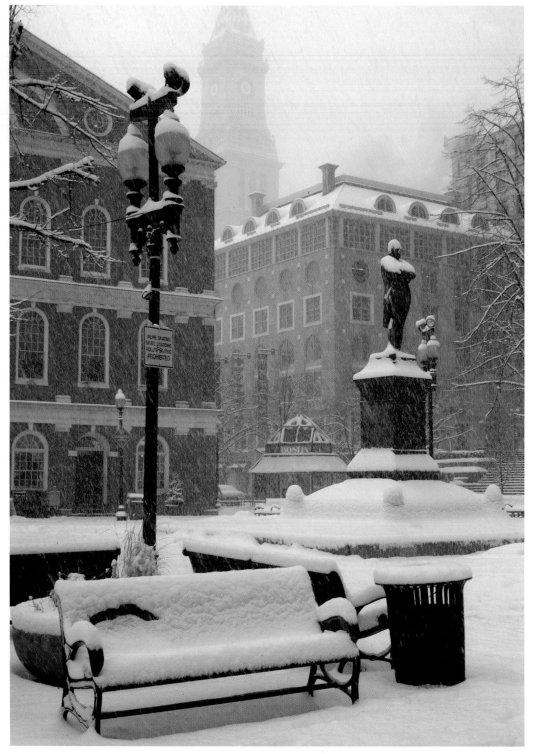

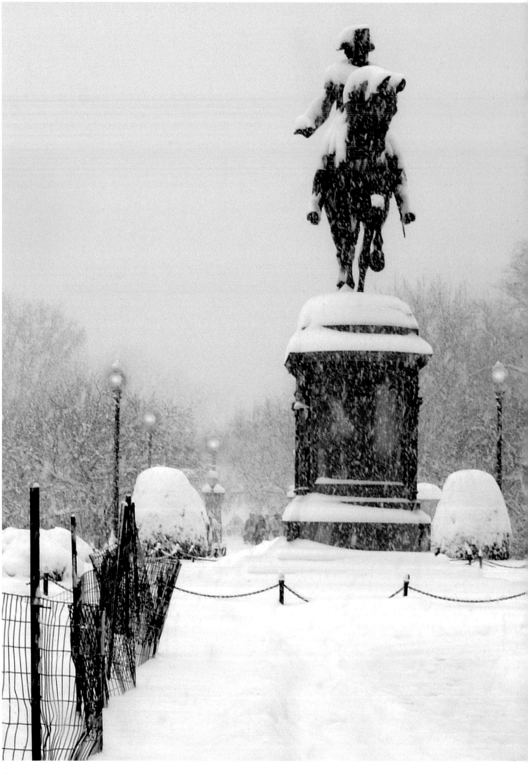

George Washington welcomes visitors to the Boston Garden.

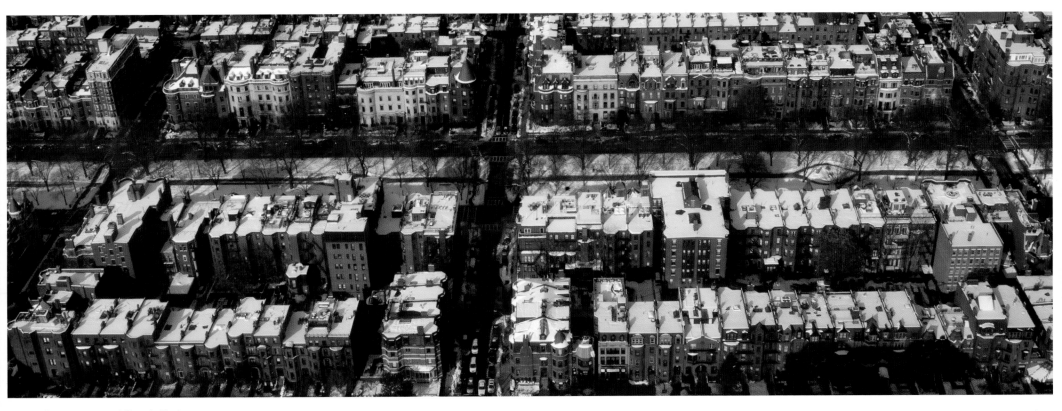

Snow covered South End

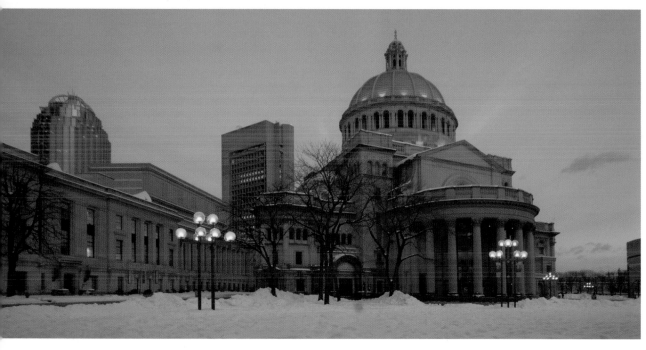

The Christian Science Mother Church on a wintry evening

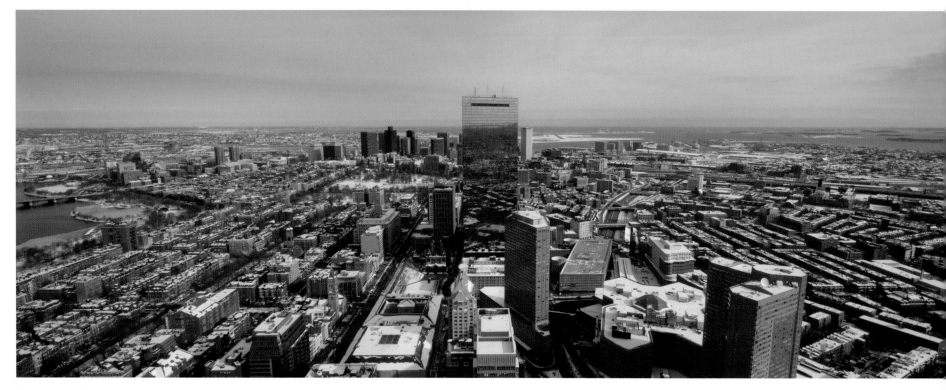

Downtown Boston

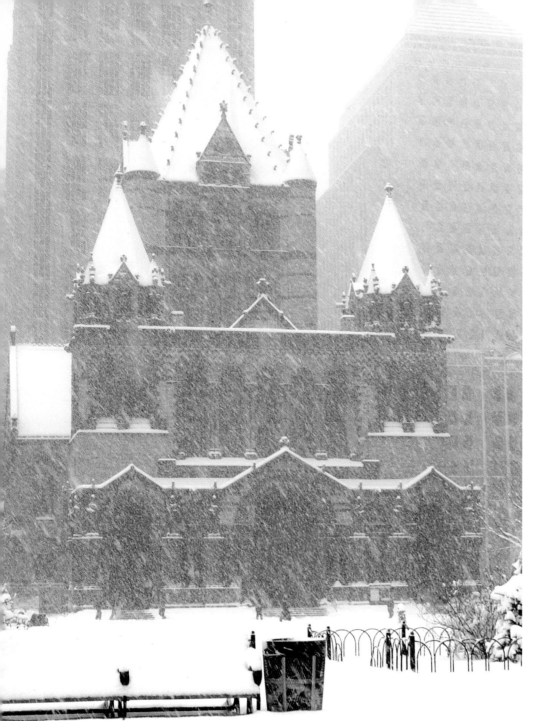

Trinity Church draped in snow

Author's Notes

This fourth Wide book is distinctively different from my previous three panoramic books. Those included primarily landscapes and seascapes with a limited number of buildings. This volume, however, concentrates mostly on buildings and areas such as parks and gardens throughout the Boston area that involve human influence. This book also has been expanded, as was South Shore Wide, with a map showing the basic location of all the images, a table of contents, and an index to help the reader find a specific locale or neighborhood.

With a project of this scope, the number of potential images is limitless; the greatest difficulty lies in deciding what should be included. Some scenes lend themselves to wide-angle photography: the harbor, lighthouses, Boston Common, and Boston Garden to name a few. Others, just as dramatic, may not have an angle of view wide enough to create a panoramic image. In previous "Wide books," there was no logistical difficulty in shooting beaches, landscapes, and a variety of common subjects in that area for that book.

Shooting images in a city involves several difficulties that are sometimes not able to be overcome. Post 9/11 security restrictions limit picture-taking opportunities at a variety of locations. In addition, many historical locations are copyrighted and do not allow any unauthorized photography. On the other hand, there were many sites that opened their doors and were extremely gracious in offering opportunities to capture images. For that reason, some of the images in this book are not commonly found in other books on Boston.

All that said, Boston is a fantastic city, easily walkable, with monuments and memories around each corner, culture and sophistication abounding in the different neighborhoods. Throughout Boston and the nearby region, there are unlimited opportunities to produce panoramic images that can be spectacular. Easy access to the harbor via the Harborwalk and trails along both sides of the Charles River offer numerous vistas to create wide-angle images. For visitors, residents, and photographers, I hope this volume motivates, encourages, and inspires you to enjoy Boston.

Index

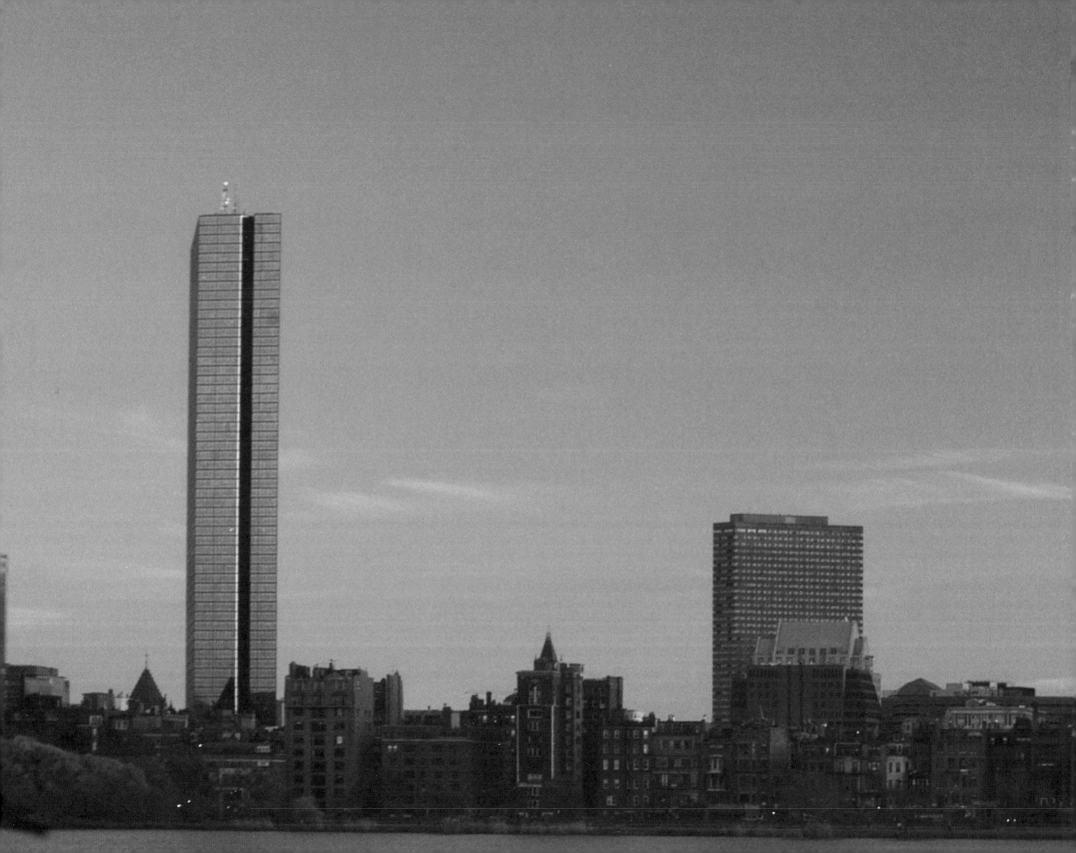